IMAGES OF WAR

BLITZKRIEG POLAND

RARE PHOTOGRAPHS FROM WARTIME ARCHIVES

JON SUTHERLAND AND DIANE CANWELL

Pen & Sword

MILITARY

First published in Great Britain in 2010 by
PEN & SWORD MILITARY
an imprint of
Pen & Sword Books Ltd,
47 Church Street,
Barnsley,
South Yorkshire.
S70 2AS

A CIP record for this book is available from the British Library.

ISBN 978184 884 3356

Typeset by S L Menzies-Earl

Printed and bound by CPI

Pen & Sword Books Ltd incorporates the Imprints of
Pen & Sword Aviation, Pen & Sword Maritime, Pen & Sword Military,
Wharncliffe Local History, Pen & Sword Select, Pen & Sword Military
Classics, Leo Cooper, Remember When, Seaforth Publishing and
Frontline Publishing.

For a complete list of Pen & Sword titles please contact
Pen & Sword Books Limited
47 Church Street, Barnsley, South Yorkshire, S70 2AS, England
E-mail: enquiries@pen-and-sword.co.uk
Website: www.pen-and-sword.co.uk

Contents

Introduction .. 4

Chapter One
Signals Collection ... 7

Chapter Two
The German Medical Service in Poland 70

Chapter Three
SS Officer's Album ... 85

Bibliography .. 112

Introduction

The German Army began a highly secret mobilisation on 26 August 1939. It was to launch Operation *White*, the invasion of Poland. Full mobilisation would be completed by 3 September. The invasion of Poland, which triggered the Second World War after a series of threats, counter threats and declarations of war, began on 1 September.

The Germans mustered over 1.5 million men in two army groups, amounting to some fifty-three divisions. They attacked Poland from three different directions; *Generaloberst* Fedor von Bock's 3rd and 4th Armies, known as Army Group North, struck from north-east Germany and east Prussia. *Generaloberst* Gerd von Rundstedt's 8th, 10th and 14th Armies, or Army Group South, invaded from south-eastern Germany and northern Slovakia. They were supported by the 1st and 2nd Slovak Divisions. The Germans had mustered thirty-seven infantry divisions, four motorised divisions, six panzer divisions, three mountain divisions and three light divisions.

Ranged against them was the Polish Army of 1.1 million men. Many of these divisions were positioned very close to the German border and found themselves quickly outflanked and out-manoeuvred. In all, the Poles had forty infantry divisions, eleven mounted cavalry brigades and two mechanised divisions.

The Germans had sought an excuse for launching their assault on Poland. One such incident had taken place on 31 August, when German agents, dressed in Polish uniforms, had attacked the German radio station at Gleiwitz, in Upper Silesia. This incident was part of Operation *Himmler*, to simulate Polish aggression against Germany and thereby give the Germans a reason to launch an invasion of Poland and carry out other reprisals.

The German invasion of Poland was a short but hard fought affair. Polish forces tried to withdraw and set up better lines of defences to the east. On 17 September 1939 an even more decisive hammer blow fell on Poland when Soviet forces invaded from the east. By 6 October the Polish Army had been defeated in the field. Germany annexed Western Poland and the Soviet Union annexed agreed portions of Eastern Poland. The two countries had entered into a secret agreement to partition Poland.

The photographs in this book come from three different photo albums, the first of which appears to be one owned by a German officer of the German Army

Medical Corps. Many of the photographs in this collection focus on rear echelon activities and show the wide variety of different vehicles used by the corps. The second album is a little more difficult to identify, but it does contain a number of combat situations and the primary clue as to the nature of the work carried out by the officer are the tactical signs on some of the vehicles used. They appear to suggest that he was attached to a motorised signal company. The final collection is believed to have belonged to a former SS officer. It is possible that he was an army field gendarme, effectively the German military police. This is borne out not only by the uniforms and the equipment, but also the selection of vehicles that are pictured in the album, which includes field cars and Opel Blitz trucks. Some of the men also have equipment for traffic control.

We are indebted to the owner of these albums, James Payne, for his permission to use them in this photographic record of the first campaign of the Second World War.

This was a campaign in which the Germans were first able to use their *blitzkrieg* techniques against an enemy. For the first time the use of the army and air force in particular was brought together to provide a mutually supporting and devastating strategy against the enemy. *Blitzkrieg* can be literally translated as lightning war; it would be used to enormous effect by the Germans throughout the Second World War, not only in Poland, but also against the Low Countries, France, the Balkans, Russia and North Africa. The Germans would deploy their air forces to attack on a narrow front whilst paralysing the communications network between the enemy's front line and its command. Ground forces, spearheaded by tanks and mechanised infantry, would then punch holes through the enemy defences. Slower-moving units would move up behind to secure the spearhead's flanks and to mop up isolated enemy units. The spearheads would thrust on, inflicting devastation in the rear areas of the enemy's lines. All the time they would be covered by aircraft. The armoured forces would fan out, isolate enemy units into pockets and launch assaults from the rear. This was a fast-moving, devastating and revolutionary tactic that aimed to ensure a quick and decisive victory. It used the latest military technology and, above all, it avoided the ruinous, static stalemates that had typified the First World War.

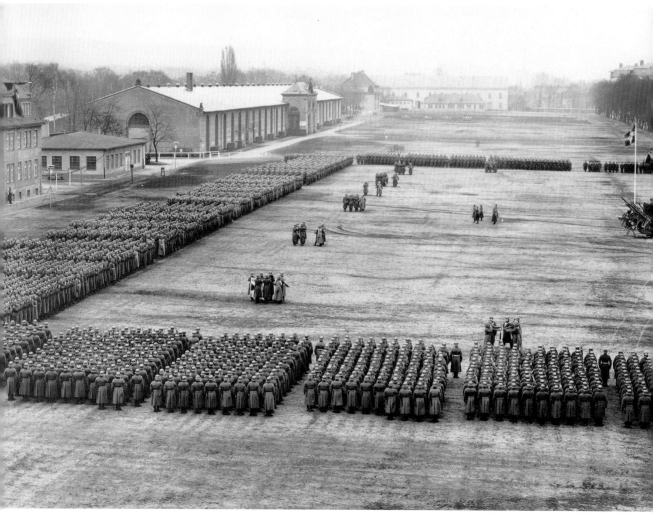

We can assume that this photograph was taken of the parade ground at Insterburg in East Prussia at some point before the invasion of Poland. A number of large barrack complexes had been built in East Prussia by the Germans in the 1930s, although some of the barracks dated back to the late-1890s. East Prussia, although part of Germany, was effectively cut off after the First World War. West Prussia had been restored to Poland and the Memel Territory was annexed by Lithuania. Within East Prussia itself during the 1930s attempts were made to Germanise the region. In 1939, 85 per cent of the 2.49 million inhabitants were ethnic Germans. East Prussia would prove to be a very important jumping-off point for the planned invasion of Poland. It appears from the photograph that the men of the 1st Infantry Division are organised by company and are in full dress uniform.

Chapter One

Signals Collection

This first, and largest, set of photographs almost certainly belonged to an officer who was part of the Signals Battalion (*Nachrichten Abteilung*) 1, which was part of the German 1st Infantry Division. It had been mobilised as part of the first wave in August 1939. The infantry division had been originally formed in October 1934, at Königsberg in East Prussia. In 1936 it was transferred to Insterburg and the 1st Infantry Division was part of the XXVI Army Corps, which itself was part of General von Kuchler's 3rd Army and part of von Bock's Army Group North.

The division saw combat when it took part in the invasion across the East Prussian border. Their task was to break through the Polish lines to the north of Warsaw. To achieve this they had to overcome the Polish city of Mlawa, which was protected by strong fortifications and the 20th Polish Infantry Division, supported by a cavalry brigade. The 1st Infantry Division failed in its attempts to break through, but other German units had broken through in other places and a gap had developed, which split the Polish 20th Infantry from their supporting cavalry brigade. This meant that the Poles had to pull out of Mlawa to new positions to the south, along the Vistula River, just north of Warsaw.

The 1st Infantry Division was engaged along the border region between 1 and 4 September 1939. It then moved south and east, crossing the Narew River and the Bug River. It was then engaged in fighting around Wegrow and Garwolin. By the end of the Polish campaign it was to the east of Warsaw, near Siedice. During the Polish campaign the division was commanded by *General der Infanterie* Joachim von Kortzfleisch, who remained in command until April 1940.

The 1st Infantry Division would see limited action during the French campaign of 1940. It would then spend from June 1941 to September 1943 operating on the Russian front, as part of Army Group North. In January 1944 it was transferred to Army Group South where it fought in the Ukraine. It rejoined Army Group North in April 1944, where it remained until August. The division found itself trapped in East Prussia by the end of January 1945. On 19 February, at 0400 hours, led by a

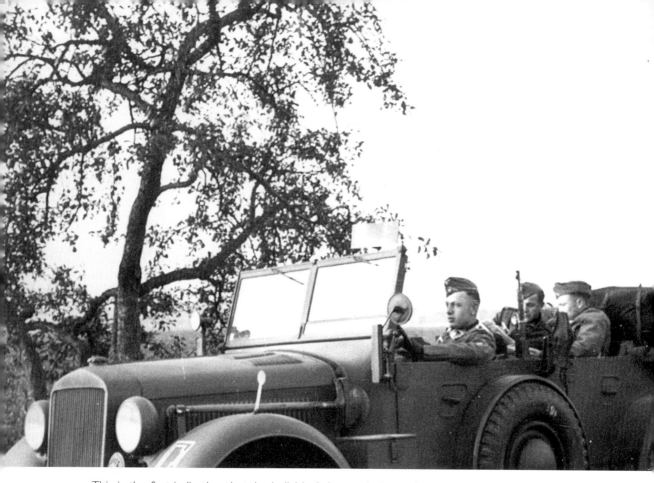

This is the first indication that the individual that took these photographs belonged to the signals unit that was part of the 1st Infantry Division. Just visible on the front mudguard is a German military field symbol denoting a signals unit. In later photographs we can clearly see the number one alongside this, denoting the 1st Infantry Division. It is unclear whether this photograph was taken before the invasion began on 1 September 1939, but the men are certainly equipped for action.

Throughout this set of photographs the men wear a variety of headgear. In this shot they are wearing their service caps, field tunics, plain trousers, marching boots and, where appropriate, grey gloves (usually worn by non-commissioned officers). In addition to this they would have their field equipment, such as a pistol in a holster or a rifle with a bayonet.

captured Russian tank, the division spearheaded an attack towards the west to help break out from Russian encirclement. The surviving elements of the division surrendered shortly after the fall of Königsberg on 9 April 1945.

The signals units had been an integral part of the division since 1934, when the division consisted of just two infantry regiments, an artillery regiment, a pioneer battalion and the signals unit.

A selection of German field cars, trucks and lorries, all designed for specific signals work. A number of the vehicles to the rear of the photograph are Kfz 31 vehicles and also visible are Krupp light trucks. To the front there also appears to be a number of different variations of Horch field cars. The Horch field car Kfz 15 was a good all-round vehicle and used for command and liaison. This particular version, the Horch 830R, was a rear-wheel drive army signals car. It was built between 1934 and 1937 and had a maximum speed of 110 km/hour and was powered by a V-8 engine. As we can see from this photograph, a wide variety of different non-armoured vehicles were used by the signals unit, many of them resembling civilian vehicles with the minimum of conversion for combat work.

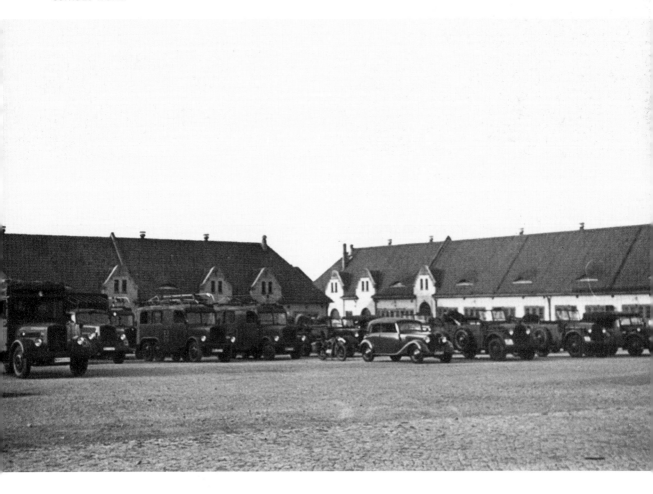

On manoeuvres in East Prussia, prior to the invasion. Although the six panzer and four light divisions would provide the spearhead of the attack on Poland, much of the hard fighting and seizing of territory would fall to the infantry divisions. Hundreds of armoured cars, tanks and other motorised vehicles would be used in the invasion. The Polish airfields and headquarters and cities would be reduced by large-scale German *Luftwaffe* raids. They targeted troop concentrations, lines of communication, gun emplacements and anti-aircraft defences. Even villages, farms and isolated buildings were attacked. On the first day alone Warsaw was raided on six occasions, primarily in an attempt to destroy the bridges across the River Vistula. As time wore on the Polish Air Force's ability to try to intercept these raiders was extinguished.

A fleet of signals field cars parked up in a town in East Prussia. The bulk of the 1st Division was based in Insterburg and the signals unit was commanded by *Oberleutnant* Stenzel. Insterburg was founded by the Teutonic Knights in the fourteenth century. The settlement grew up around a castle and it became part of the Duchy of Prussia and later the Province of East Prussia within the Kingdom of Prussia. It became part of Germany in 1871. After the Second World War it was transferred from Germany to the Soviet Union and the majority of its German population evacuated.

In 1946 Insterburg was renamed was renamed Chernyakhovsk in honour of the Russian Second World War general Ivan Chernyakhovsky. He was killed during the Battle of Königsberg on 18 February 1945. He was the youngest (thirty-nine years old) front-line commander of the Second World War. He was killed after being hit by shrapnel during a visit to the front.

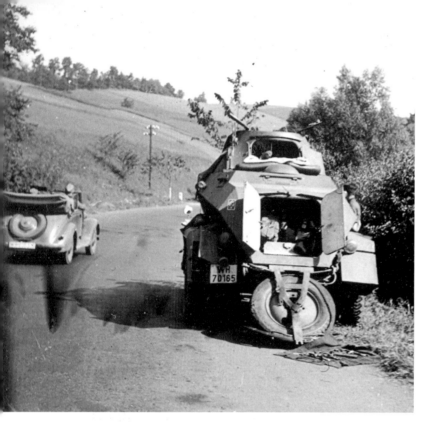

A broken down SdKfz 221, which was a light armoured car that was used for reconnaissance duties. It was based on a heavy four-wheel passenger car chassis and the turret was open. The armament consisted of a single machine gun. The cars were produced between 1935 and 1940, with modified versions coming in during 1942. It had a crew of two men, a road speed of 90 km/hour and a range of some 320 km. The engine, as can be seen in the photograph, was at the rear and was a Horch 3.5 litre. Later models were specifically designed to provide mobility and armoured protection for signals units and known as the SdKfz 260. Nearly 500 of these versions were built between 1940 and 1943.

The full complement of the infantry division's signals unit – a mix of field cars, trucks, lorries and motorcycles. This photograph was presumably taken shortly before the division was deployed for the Polish campaign. The vehicle that can just be seen to the centre right of the photograph, with the frame above, is a radio truck; this was an integral part of the signals unit. A typical German infantry division in 1939 would have a strength on paper of 16,500 men. They would have 500 trucks, 400 passenger cars, 500 motorcycles and 200 motorbikes with sidecars, but they would still be reliant on horse-drawn transport, with up to 1,000 covered wagons. At the time of the Polish campaign the division mustered three infantry regiments: 1, 22 and 43. In addition it had artillery, a machine gun battalion, an anti-tank battalion, a reconnaissance battalion, a pioneer or engineer battalion and a medical unit, along with the signals battalion.

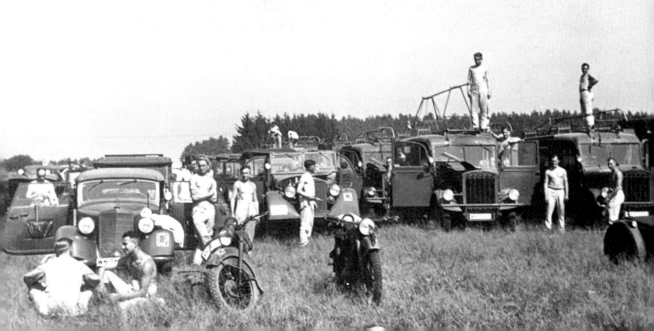

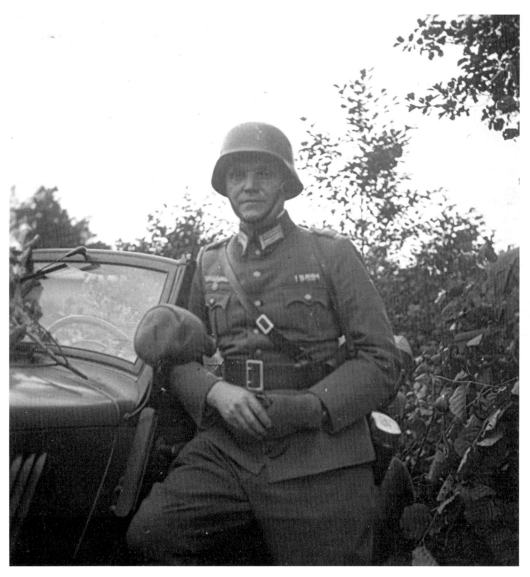

This is an officer of the signals unit. The German regulations of April 1935 required ten different orders of dress in peacetime for officers. There were two ceremonial uniforms and a parade uniform (formal), a walking out and reporting uniform (semi-formal), a service uniform and an undress and guard uniform for duties in the barracks, a field uniform and a sports dress. From October 1939 most officers in combat units were ordered to wear the M1935 other ranks field tunic, trousers and marching boots. In practice, however, many officers continued to wear their original uniforms. This officer has opted to wear his helmet rather than an M1934 or M1938 field cap. Personal weapons would usually be either a Luger or a Walther pistol and many would also carry black binoculars, in either a leather or Bakelite case, on the right, front hip. This officer appears to be wearing an M1935 steel helmet, although the *Wehrmacht* eagle is not visible in this photograph. It is also difficult to see his shoulder straps, which would indicate his branch insignia. In practice, in battlefield conditions, these would be removed for security purposes.

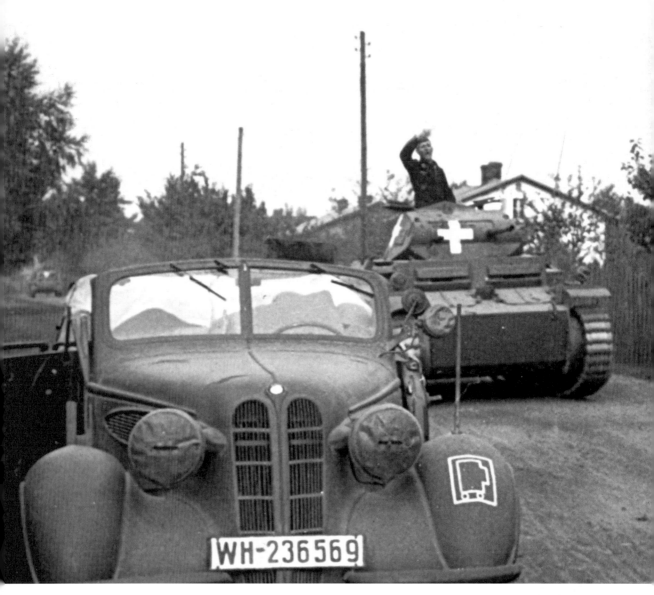

This photograph shows a Panzer II tank. Its main armament of a 20-mm cannon was adequate at the time; it was effective against soft targets, but would struggle against enemy armour. In all likelihood this tank belonged to an *ad hoc* combined arms unit that was created in East Prussia for the Polish invasion. It was known as Panzer Division Kempf, but it was only around half the strength of a standard panzer division. It was actually no larger than a reinforced brigade. It is very likely that they were involved with the 1st Infantry Division, as they were operating in the same area at the same time. The tank unit was disbanded following the end of the campaign and this tank may well belong to the 7th Panzer Regiment, which was assigned to Panzer Division Kempf on 1 September 1939 and then reassigned to the 10th Panzer Division on 10 October. The regiment would see considerable action, but it would be part of the German forces that surrendered in Tunisia in 1943.

This is a signals rider on a motorbike, in front of a field camp, probably in the forward area immediately prior to the invasion. The commander of the division, Joachim von Kortzfleisch, had an interesting military career. He had joined the army in 1907 and had reached the rank of *generalmajor* by 1937. As *generalleutnant* he commanded the 1st Division at the outbreak of the war. By September 1940 he was commander of the XI Army Corps and had been awarded the Knight's Cross of the Iron Cross. On 20 July 1944 he was commander of Defence Group III, Berlin. The attempt to assassinate Hitler had failed, but the conspirators were trying to gain control of the German capital. The plotters arrested von Kortzfleisch and he refused to take part in the coup. After the coup attempt had failed he returned to his duties. In March 1945 he became the commander of the Rhine bridgehead and was captured by members of the US 737th Tank Battalion on 20 April; he was shot whilst trying to escape.

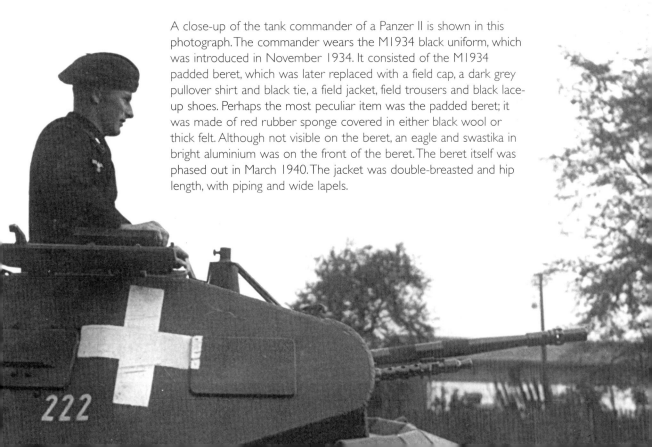

A close-up of the tank commander of a Panzer II is shown in this photograph. The commander wears the M1934 black uniform, which was introduced in November 1934. It consisted of the M1934 padded beret, which was later replaced with a field cap, a dark grey pullover shirt and black tie, a field jacket, field trousers and black lace-up shoes. Perhaps the most peculiar item was the padded beret; it was made of red rubber sponge covered in either black wool or thick felt. Although not visible on the beret, an eagle and swastika in bright aluminium was on the front of the beret. The beret itself was phased out in March 1940. The jacket was double-breasted and hip length, with piping and wide lapels.

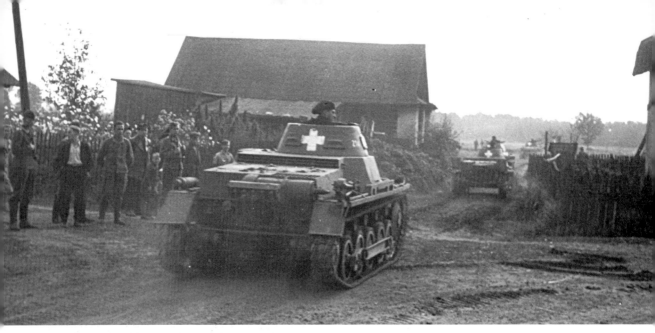

A column of Panzer moving through a farm can be seen here. Again we can see the black uniform that distinguishes the panzer units. On the collar there were skulls, which harked back to the Imperial German cavalry. All ranks would wear shoulder and sleeve rank insignia. The black, plain trousers were tapered at the bottom and they were buttoned and tied at the ankle. The Panzer I entered production in April 1934 and was produced in two main, but similar, variants. The Panzer I had first seen action during the Spanish Civil War but by late 1938, however, it was clear that the Panzer I was not ideal as a combat tank. It was therefore developed into a reconnaissance or light infantry tank. It was armed with a pair of machine guns; some 973 of these vehicles were used across the various units during the Polish campaign. Panzer Division Kempf deployed sixty-one of them.

German troops interrogate civilian Polish prisoners in this picture, whilst their transport is parked under the tree canopy to the rear. These men are wearing standard 'other ranks' field tunics in field grey. Their collar patches have bluish dark green facings. We can also see that the men have their 84/98 service bayonets, which were carried in a blue, steel sheath suspended from the belt. They also have standard ammunition pouches in black leather, with aluminium fittings, and they carry the Karabiner 98k rifle. Also visible are the gas mask canisters, entrenching tools, mess kits, bread bags and canteens. The men's backpacks were usually left in the unit's transport, which would allow the men more freedom of action, so that they could fight in light order.

The signals unit, with what we can assume to be a friendly, local Polish guide. Note the equipment in the back of the vehicle, including rifles, canteens and groundsheets. There were estimated to be around a million Germans living in Poland in the 1930s, a large number of whom lived in West Prussia. Allegedly, several thousand ethnic Germans were killed by the Poles during the Polish campaign in retribution. The suppression and violence against ethnic Germans in Poland was one of the many reasons Hitler used to justify his invasion of the country in 1939. After the war large numbers of ethnic Germans were expelled from Poland, many of them finding their way into either the British or American occupation zones in Germany or the Soviet-occupied East Germany.

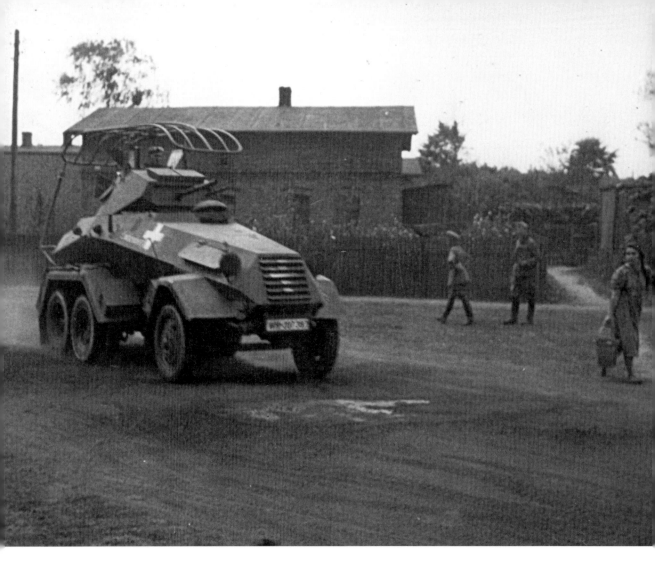

This is a SdKfz 231 6RAD. Again, it was based on a commercial chassis, this time a truck. It was effectively a six-wheeled armoured car; basically an armoured body mounted on a modified truck chassis. The SdKfz 263 6RAD was produced up to 1937 by Daimler-Benz. These were issued to signals units and they remained in active service throughout the Polish and French campaigns. They had a four-man crew and the Daimler-Benz model had a six-cylinder engine. It had a road speed of 70 km/hour and a range of around 300 km. The SdKfz 263 only had a machine gun, but clearly this model has a 20-mm cannon fitted. The frame over the top of the vehicle indicates that it is fitted with radio equipment.

By the late 1930s the Germans had decided to shift production from six-wheeled armoured cars to eight-wheeled versions. Nonetheless, the six-wheeled armoured cars were still used up to the invasion of Russia in 1941. After this time they were withdrawn for training and internal security duties. The radio version was fitted with a 100-watt long-range radio and frame aerial. The turret was hand-traversed but could still move freely beneath the frame. It is difficult to say whether or not this vehicle was attached directly to the signals unit, or whether it was an integral part of a panzer regiment operating in the same area.

A pair of SdKfz prime movers, towing howitzers. Note that the vehicles are open-topped and use theatre-style seating for the gun crews. This was an iconic vehicle of the Second World War. It was widely used by all elements of the German army and the *Luftwaffe*. It can be traced back to 1934, when it was decided that there was a requirement for an 8-ton halftrack that could be used to tow either a 15-cm howitzer, as it is doing in this photograph, or the 88-mm FlaK gun. The first vehicles came off the production line in 1938 and they could carry twelve men and were capable of towing 8,000 kg. The vehicles had fold-down windshields and were equipped with a canvas roof. The front wheels had hydro pneumatic tyres and the track consisted of seven wheels that overlapped on each side. They had very good off-road mobility and were powered by Maybach six-cylinder engines. They had a top speed of 50 km/hour and an operational range on the road of 250 km.

A number of variants of the vehicle were produced over the course of the war, with FlaK guns fitted onto the structure of the vehicle or as observation and command posts for rocket launchers. Between 1939 and 1945 over 12,000 of these vehicles were produced. There were still 3,602 of them in service in March 1945, despite the fact that only 270 new vehicles had been built that year.

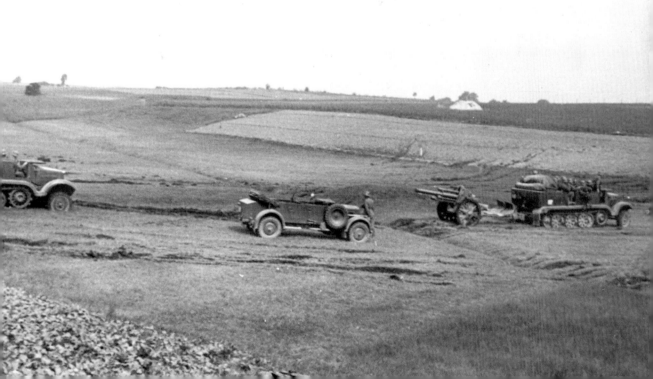

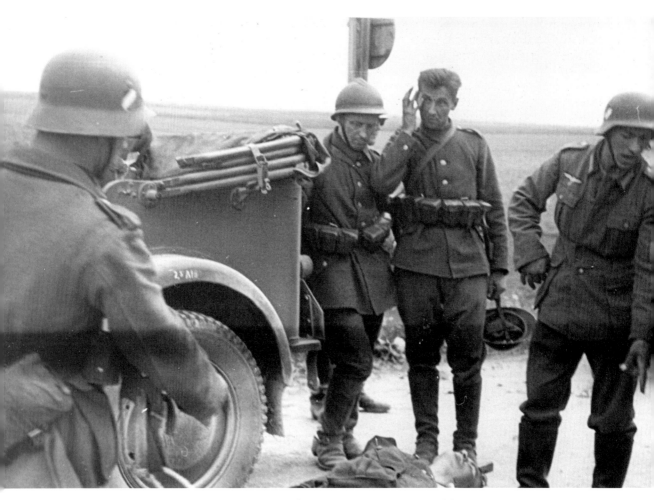

German troops with captured Polish infantrymen are shown here. Of particular interest is the fact that the Poles have the French-style Adrian helmet. They are also wearing 1936 patterned jackets and their ammunition pouches are for their Mauser 1898 rifles. They are both wearing boots with the possibility that the man on the left has spurs, which could imply that the men are actually from a Polish Uhlan (lancers) regiment. This would be consistent with the operations of the 1st German Infantry Division, as they encountered Polish cavalry units during their part of the campaign. If this is the case then these men would have been part of the Mazowiecka Cavalry Brigade. They operated in conjunction with the Polish 20th Infantry Division against German troops advancing from East Prussia. There were two Uhlan regiments: the 7th and the 11th. Units from this Polish cavalry brigade were involved in some of the last examples of mounted warfare when they engaged elements of the German 1st Cavalry Brigade hand-to-hand.

Transport elements of the 1st Infantry Division, including an ambulance and motorcycles and sidecars. Also visible in the centre of the photograph is a four-wheeled armoured car, which is almost certainly a SdKfz 221. Visible in the foreground is the classic BMW motorcycle combination. The BMW R-75 heavy motorcycle, or, more accurately, the BMW R-75 with sidecar, Schweres Kraftrad 750 cc mit Seitenwagen, was undoubtedly the most popular German motorcycle of the Second World War, with over 16,000 of them being built. It was used extensively on all fronts during the war, from North Africa to Russia, and proved to be extremely reliable and adaptable to the most hostile terrain. It had a 26-hp engine, which drove the rear and sidecar wheel via a four-speed (and reverse) gearbox. The R-75 had hydraulic brakes on the drive wheels and mechanical brakes on the front and was fitted with telescopic front forks. The vehicle was extensively used as a reconnaissance vehicle, a role which was later taken over by the Kübelwagen.

Reconnaissance battalions would be issued with a mix of BMW R-75 combinations and Kübelwagens and were able to cover enormous distances and remain mobile enough to avoid any serious action. There were a large number of them fitted with a bar mount on the sidecar to take an MG 34 machine gun. In service with the Africa Corps it was common practice to cover the breech of the gun with a canvas cover to prevent it from being fouled by the sand. The vehicle not only had side panniers for ammunition supplies and other equipment, but also had valises mounted on the sidecar to house additional MG 34 machine gun ammunition.

The Germans also used the BMW R-12 heavy motorcycle which was built between 1935 and 1941. It, too, had a 746 cc air-cooled two-cylinder engine and was used either as a solo vehicle or, in some cases, with a sidecar.

The other major German heavy motorcycle of the period was the Zundapp KS750 heavy motorcycle which was also widely used and could be fitted with a sidecar. It too had a 751 cc overhead valve air-cooled engine. The engine drove the rear wheel of the motorcycle as well as the sidecar in the same way as the BMW R-75.

The heyday of the German heavy motorcycle was during the *blitzkrieg* period of the war, when the German Army employed more motorcycles and motorcycle combinations than any other army of its time. Whilst they were primarily used for reconnaissance, they were incredibly useful in capturing unprotected key positions, such as bridges, fords and road crossings, and could often be used to insert small numbers of men behind enemy lines to disrupt movement and communications.

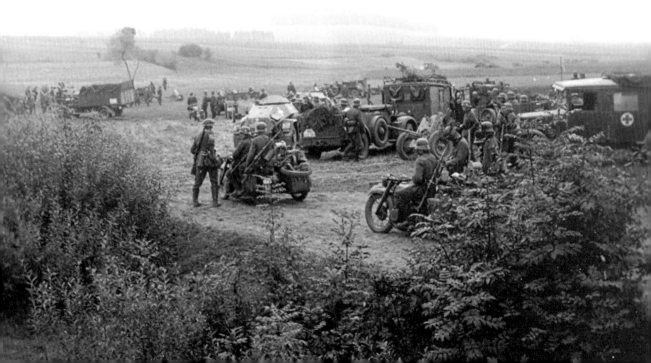

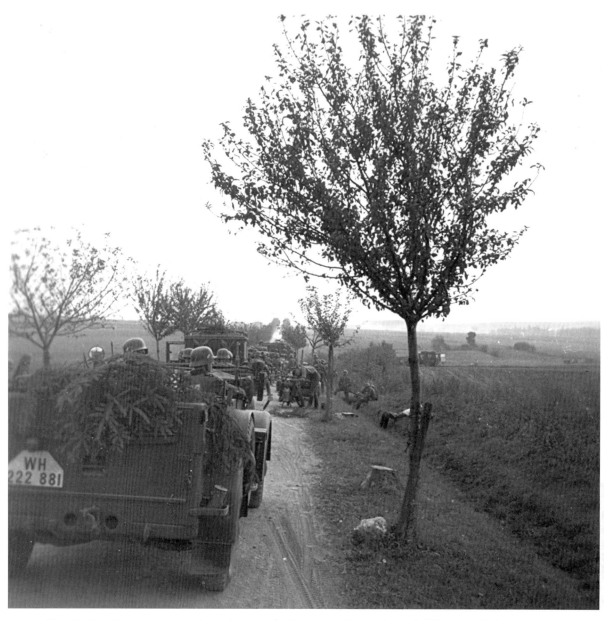

The division is on the move through Poland. Note the wide variety of different vehicles and the large numbers of motorcyclists. The first set of engagements in which the 1st Division was involved is often referred to as the battle of the border. The Poles had set up their principal defence lines along their lengthy border areas. The 3rd Army, of which the 1st Division was a part, found itself facing the Polish Army, Modlin. The engagements took place around Mlawa between 1 and 3 September 1939, after which the Polish forces were compelled to withdraw to their secondary lines of defence.

The battle itself began with a heavy artillery bombardment. At first, Polish troops started to waver but despite everything the Polish Army held out and it was not until 3 September that German engineers penetrated the Polish anti-tank barriers. This allowed them to capture bunkers on the left flank of the Polish lines. Although progress was still slow, it had become abundantly clear that if the Polish troops remained in place they would be outflanked and surrounded. Consequently, they finally abandoned their fortified positions.

A number of German Panzer IIs are parked alongside a road in Poland in this photograph. The history of the Panzerkampfwagen II dates back to 1934, when the German Ordnance Department issued a specification for a light tank weighing no more than 10 tons, armed with a 20-mm automatic cannon. Several German manufacturers offered solutions but the MAN version was accepted. Limited production began in 1935 with the Ausf A1, with the A2 and A3 offering improvements to the engine and suspension.

By 1939, 1,226 were in service but it became clear that the armour was inadequate, despite the fact that the Panzerkampfwagen II had been the most common tank used both in Poland and France by the German Army. Production continued and in 1941 the Ausf F (233 built) appeared with slight variations, including additional armour. By the eve of the Russian invasion, over 1,000 of these vehicles were available, some of which had been refitted with a French 37-mm gun.

It is, perhaps, significant, that despite the continued production, the number of these tanks in service had dropped to 866 by April 1942. From this year increasing numbers of the chassis were being used to create self-propelled guns capable of penetrating Russian armour, most notably the Marder II. Between 1942 and 1943, 531 Panzer IIs were converted into this tank destroyer. The chassis was also used to create the Wespe, of which 682 were converted between 1943 and 1944. In 1940 some 95 Panzer IIs were converted into Flammpanzer II flamethrower vehicles. The final development of the Panzer II was the Panzerspähwagen to Ausf L Luchs (Lynx) or the SdKfz 123.

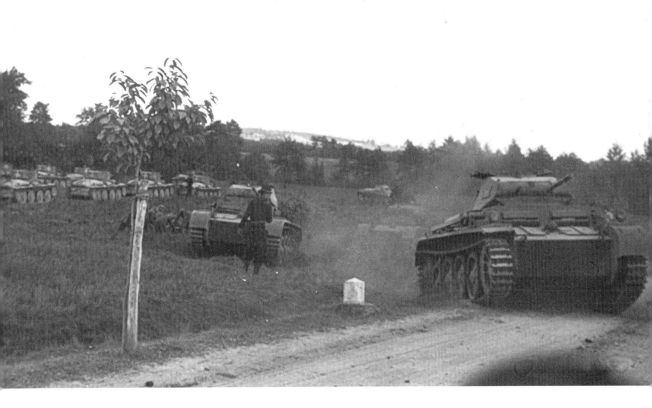

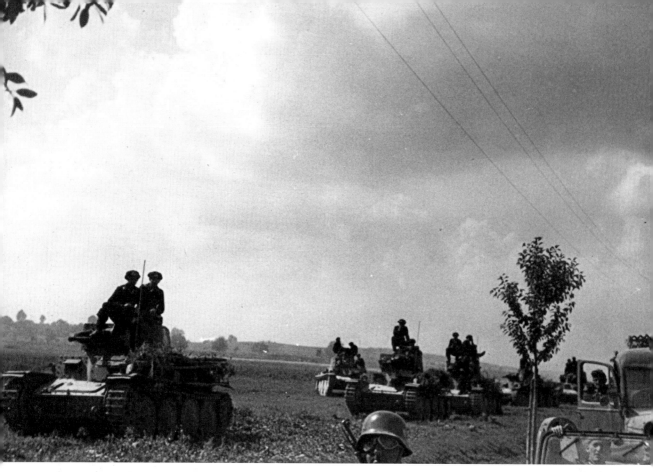

More German tanks, but this time they are captured Czechoslovak 38(t)s. Following the occupation the first 150 production models were re-designated the PzKpfw 38(t) Ausf A SdKfz 140 and it remained in production until June 1942. Captured vehicles were even used by the Russians and one by the British. Around 1,400 of the tanks were produced; the various modifications improving the armour protection, particularly the fact that the riveted construction proved lethal to crews if the armour plate took a direct hit. The riveted structure was replaced with welded plates. Some 38(t) vehicles were converted into flamethrowers whilst many others did sterling service in the German Army as anti-tank and assault guns such as the Marder and the Hetzer.

Initially, the 38(t) was used in Poland, Norway, the Balkans and Russia but by 1942 it was apparent that its armour and armament were inadequate. Consequently, the chassis was adapted for use as the Marder III, the Flakpanzer 38(t) and the Aufklarungspanzer 38(t) (armed with a 20-mm or 75-mm gun).

One of the 38(t)'s most successful conversions was as the Jagdpanzer 38 Hetzer, a tank destroyer. Some 228 38(t)s were fielded by the Germans in their *blitzkrieg* on France and the Low Countries in May 1940 and almost exclusively equipped the 7th and 8th Panzer Divisions. By the end of 1940, 432 were in service and when the Germans invaded Russia in 1941 over 750 38(t)s were in service, accounting for 25 per cent of the total German tank force.

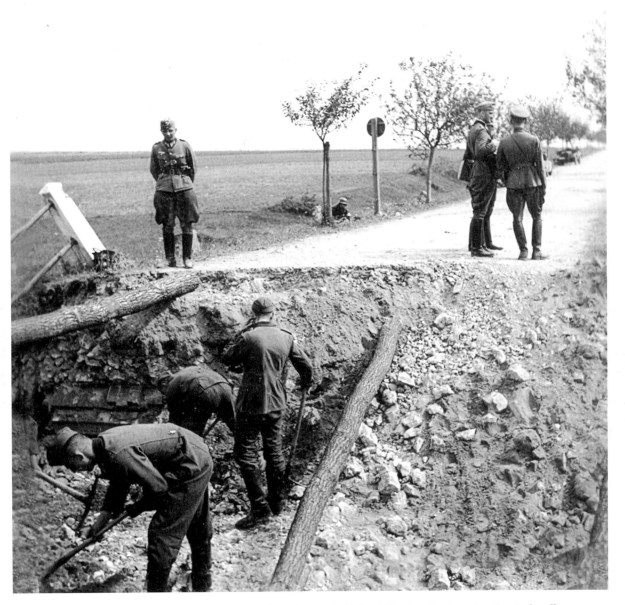

Engineers from the division repair a road or viaduct in Poland. During the invasion the *Luftwaffe* launched massive air raids on Poland, aimed at destroying the infrastructure. A sizeable proportion of the *Luftwaffe* was used for direct tactical air support. This meant bombing rail networks, crossroads and troop concentrations.

Warsaw was particularly badly affected; many historic buildings, hospitals, markets, schools and bridges were all targeted. The Jewish quarter of the city suffered 183 bomber sorties, with a mix of high explosives and incendiaries. Some 10 per cent of all the buildings of the city were destroyed and some 40,000 civilians killed. Initially, the air defence of Warsaw had been fairly successful but anti-aircraft defences began to crumble on 5 September 1939, when batteries were withdrawn to protect other cities.

Work is underway on repairing a damaged road section in this photograph. The division's engineer battalion consisted of an HQ platoon, three pioneer companies and a motorised bridging column. It would not always be possible for the engineers to be deployed directly where needed; hence engineering problems would have to be undertaken by whatever unit first encountered them. This may explain why in this photograph the men seem to lack equipment to carry out the task by hand. The 1st Division's target was initially Warsaw. The heaviest fighting took place around the line of field fortifications and concrete bunkers to the north of Mlawa. In order to cut off these Polish border forces the *Luftwaffe* would have been hard at work to destroy road networks that would also impede any retreat.

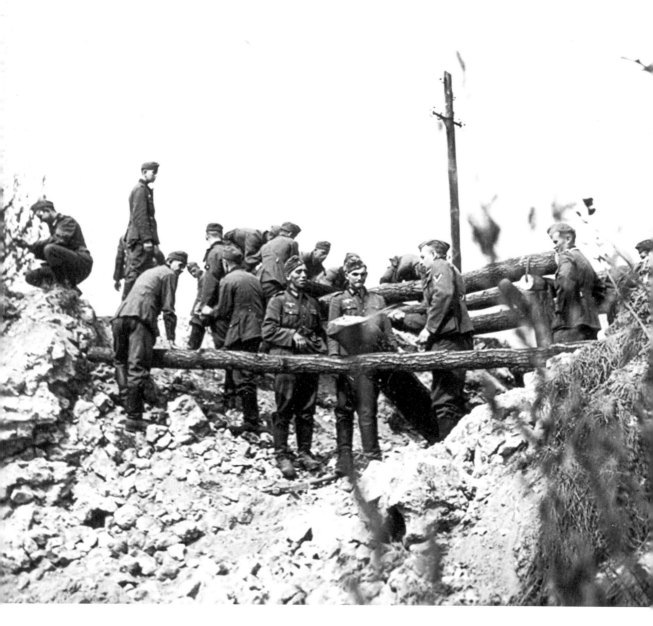

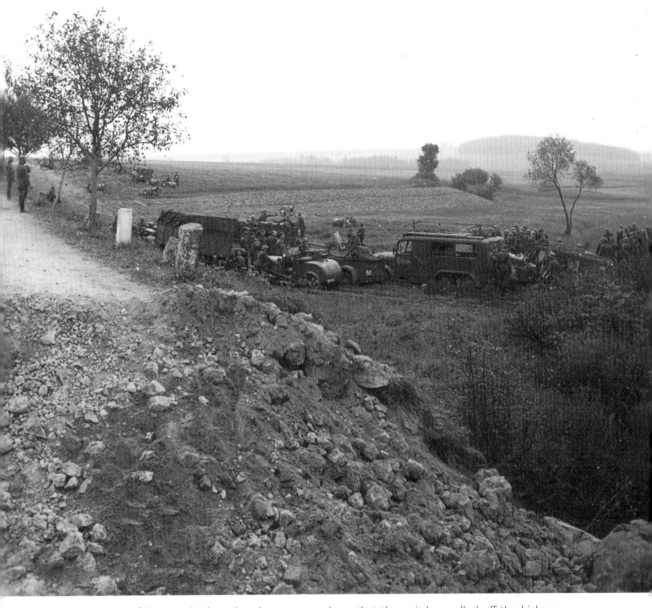

Another view of the wrecked road and we can see here that the unit has pulled off the highway and is ready to make its way across country, thus avoiding the damaged section. It was a feature of the German campaigns that forward units would doggedly pursue a retreating enemy and they would try to work their way around the flanks of enemy concentrations, in order to surround them and cut them off. They could then be softened up with aircraft attacks and, once it was clear that they could not break out of the encirclement, they would be taken into captivity in enormous numbers.

Within a matter of days the Polish Army had been so outmanoeuvred and broken up by the determined German attacks that many of the cities had already either surrendered or were under immediate threat. By 6 September 1939 Kraków had fallen and the industrial region between Kraków and Warsaw had been overrun. In fact, the western section of Poland was largely occupied within a week. The Germans had expected to achieve this within a month. The German movement was assisted by the first-rate nature of many of the Polish roads. The weather conditions were dry and sunny but despite a long chain of reversals the Polish spirit continued to remain unbroken.

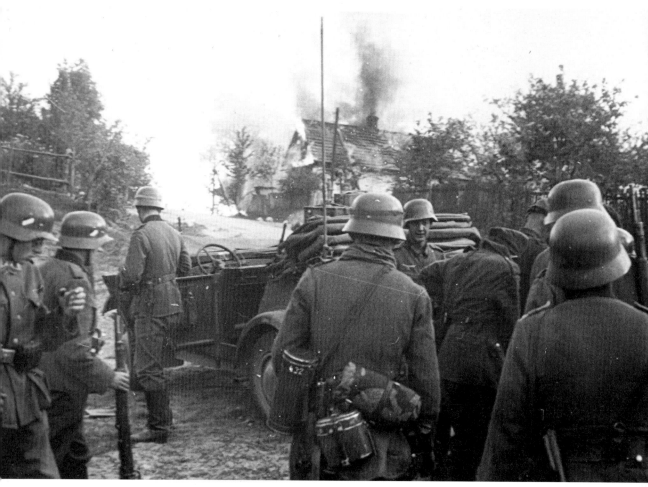

German troops pause in front of a burning Polish house. The main Polish defensive position facing the 1st Infantry Division ran along the line of the Narew and the Vistula River. The plains to the north were difficult to defend. The Poles were under instructions to hold the line for as long as practicable and then to withdraw to defend the river line. They had started their secret mobilisation in March 1939 and Mlawa was assigned to the 20th Infantry Division. Trainloads of concrete and other construction materials were moved into the region to create a line of fortifications.

By 19 June 1939 most of the construction had been completed and final approval for the defence works was given at the beginning of July. There was a line of trenches and concrete bunkers, protected by anti-tank trenches and obstacles. This protected the valley to the north of the town. The river itself was blocked by a damn; in the centre was a swampy area and the western section was reinforced by sixty-eight concrete bunkers.

A Fieseler Fi156 Storch, or Stork, flies overhead. This was a German liaison aircraft, which had been developed in the late 1930s. The first prototype was flown in the spring of 1936. The Storch was used on virtually every front by the Germans during the Second World War. For its time it was one of the most advanced in terms of short take-off and landing performance. The wings could be folded back along the fuselage and it could be carried on a trailer, or even towed behind a vehicle. Nearly 3,000 of these aircraft were built between 1937 and 1945. So useful were they that Field Marshal Montgomery used a captured one as his personal aircraft. The Storch was also the last aircraft to land in Berlin on 26 April 1945. It was also arguably the last victim of a dogfight. The aircraft had a maximum speed of 175 km/hour and a range of 380 km. It had a two-man crew and was powered by a 240-hp air-cooled, inverted V8 engine.

This is an unknown Polish town, which shows clear signs of heavy fighting and aerial bombardment. The Polish 20th Division took responsibility for the defence of Mlawa. The first German attacks lost them twenty-five tanks and the Germans decided against another frontal assault, but decided to work around the town. The 20th Division were supported by the Polish 8th Infantry Division, which held up the German advances until a major offensive overwhelmed them on 3 September. The 8th Infantry Division panicked after suffering significant casualties from German air attacks. A counter-attack launched by the division was badly organised. The 20th Division withdrew on the night of 3/4 September and by 7 September they had reached Plock on the Vistula River. Elements of the division eventually made their way to Warsaw, helping to defend it from the north-west. What remained of the division surrendered, along with the Warsaw garrison, on 28 September.

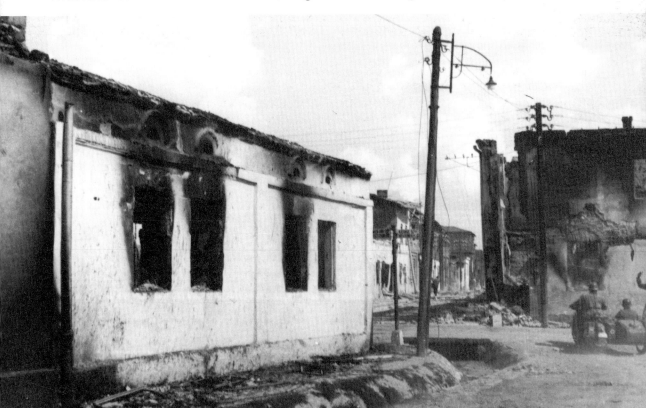

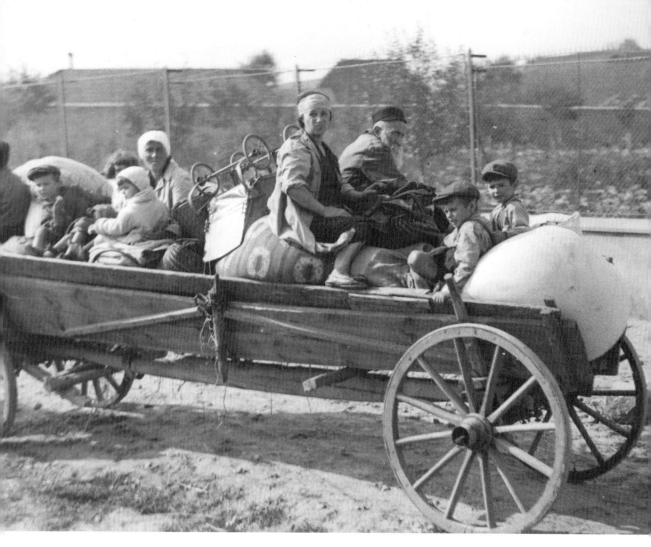

Polish refugees trying to escape the fighting on a horse-drawn cart. The arrival of the Germans in towns such as Plock posed a significant danger to the Jewish population. Plock's population was 25 per cent Jewish and virtually the entire Jewish population was eventually wiped out during the Holocaust. The towns along the Narew River had all been largely overrun by 10 September. The town of Ostroleka, for example, which had a history dating back to the eleventh century, was renamed Scharfenwiese by the Germans and became part of Germany. Literally hundreds of thousands of refugees fled the advancing German Army, trying to make for eastern Poland. The roads were clogged with carts and trucks. For those that managed to make it to the east of Poland, they would soon find themselves under Soviet control and once the Germans had invaded Russia they were to be permanently exiled from their homes in the west.

A Panzer II manoeuvres off-road. Around 1,220 Panzer IIs were used during the Polish campaign and it was the most numerous of German tanks used in panzer divisions until after the invasion of France. In the photograph we can see the commander sitting in a seat in the turret. The driver is of course not visible, but he would have been sitting in the forward hull. The crewman standing beside the tank is most likely to be the loader and radio operator. It was the tank commander's responsibility to aim and fire the gun.

The armour of the Panzer II was its weak spot; it was relatively thin, and it did not provide much protection from anything more than shell fragments and fire arms. Also, its turret ring proved to be particularly vulnerable. After the French campaign it was effectively relegated to the role of a reconnaissance tank and by 1942 the majority of them had been removed from front-line service. However, there were still Panzer IIs in service during the Normandy campaign in 1944 and some were still operational as late as March 1945. During the Polish campaign the Germans lost eighty-three of these tanks; thirty-two were lost in the fighting for Warsaw.

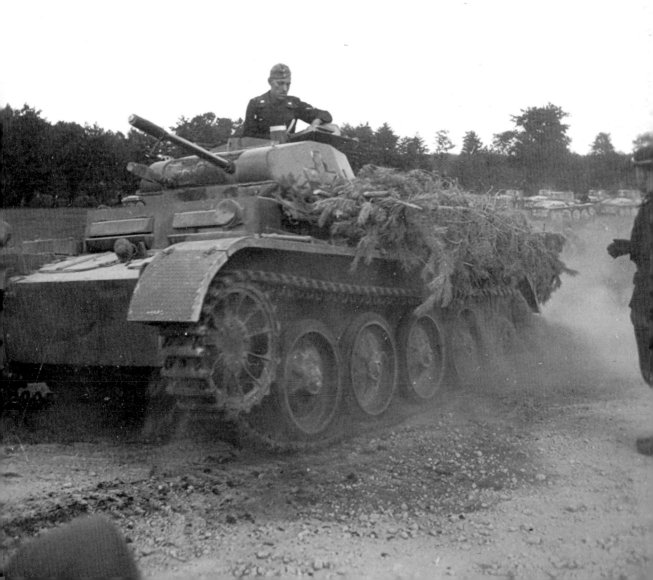

A Czech 38(t) emerges from a depression onto the road. Around 1,400 of these tanks were produced in eight different variants. The tank saw extensive service in Poland with the 3rd Light Division. It would later serve in Norway and in France, with three panzer divisions, in the Balkans and in Russia, with six panzer divisions. By 1942 it was clear that both its armament and armour were inadequate and it was relegated to a reconnaissance role. Nonetheless, the chassis was still used to create purpose-built adaptations, with FlaK guns, self-propelled guns and other armaments.

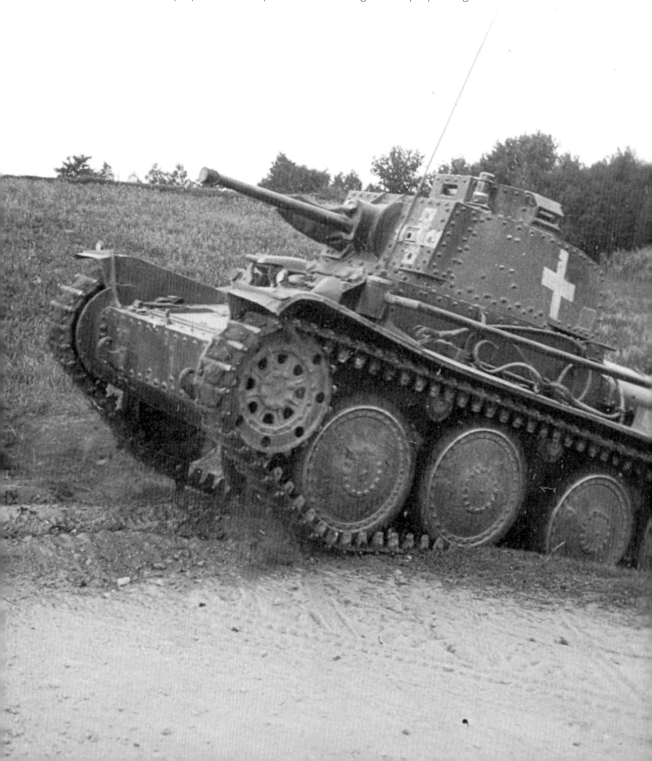

A German motorised column passes through the wrecked remains of a Polish town. The actual battle for Mlawa began at noon on 1 September 1939. The initial assault was held off by Polish artillery and by late evening the Germans had fallen back to their start positions. On 2 September the Germans launched a heavy artillery bombardment on the right flank. They threw in a major assault after two hours of artillery fire. The Polish defences began to crumble and a counter-attack by the Polish 79th Infantry Regiment failed. The 20th Polish Infantry Division was ordered to extend its front eastward and cover the right flank between the villages of Debsk and Nosarzewo. They would be supported by the 8th Infantry Division. German attacks on 3 September were also unsuccessful and it was not until the anti-tank barriers were overcome that the Germans could push through and force the Poles to withdraw.

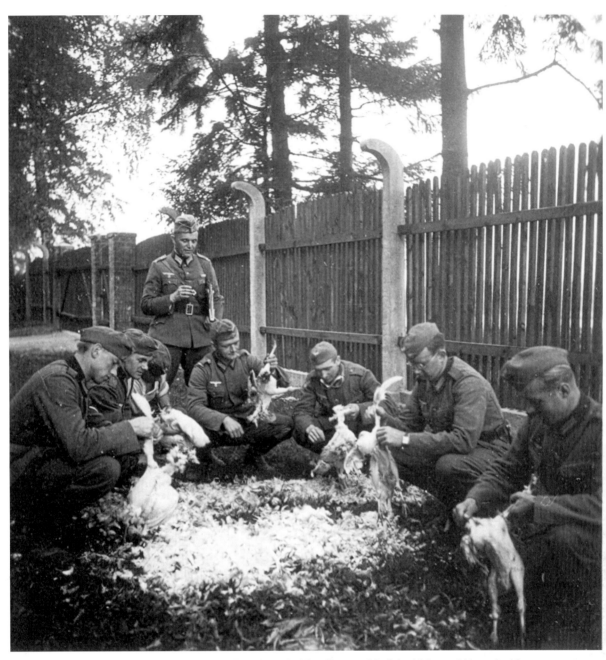

The spoils of war; here German soldiers are plucking liberated Polish chickens. Although this was a common occurrence in all wars, the Germans in fact set up a systematic plan to loot tens of thousands of art objects from Poland. The total cost to Poland was estimated to be US$20 billion; over 40 per cent of Polish cultural objects were looted during the war by the Germans. This included pieces of art, paintings, sculptures, manuscripts, maps and books. A considerable amount of this material has never been returned to Poland.

A German column halts as Polish buildings burn close by the road. As the Polish forces guarding the border areas were overrun and forced to withdraw, they fell back towards Warsaw, hoping to use the River Vistula and Bug, where they could dig in and await the assistance of their allies in the west. With the fall of Kraków the east bank of the Vistula, along with the Galician oilfields, was threatened. When Kraków fell this effectively shortened the line that the Polish Army had to hold, but the Germans were close on their heels and it was not long before the bridgeheads were being threatened by the lead elements of the German Army. As yet, despite the reversals, the Polish Army had not been demoralised. No really large pitched battle had been fought so far. The Poles were still fighting with obstinacy; there was no disorderly retreat or rout, although people were clearly concerned that Warsaw was slowly being encircled by enemy forces.

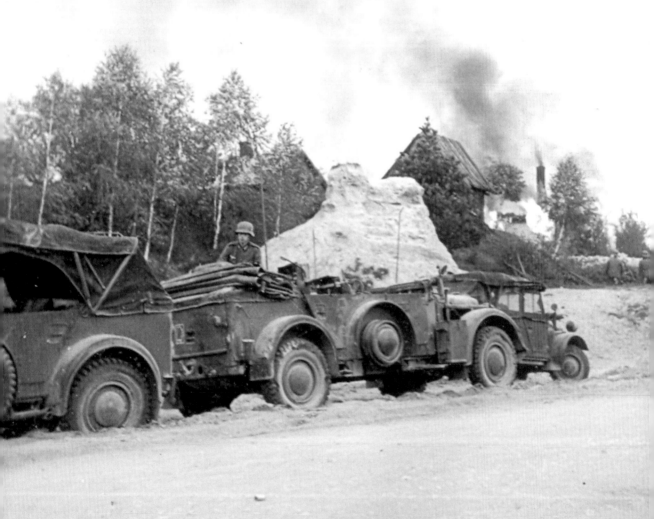

A column of Polish motorised and horse-drawn civilian traffic, forced to wait on a side road whilst German troops questioned the drivers. Particularly in western Poland, there were enormous numbers of Polish citizens of German origin, known as *Volksdeutsche*. After the occupation they were encouraged to register. They would be categorised in one of four groups; categories 1 and 2 were classed effectively as Germans. Categories 3 and 4 were those who had married Polish partners and those who were supportive of Germanisation. This amounted to literally hundreds of thousands of people. Whilst being given the status of a *Volksdeutsche* meant privileges, it also meant the contempt of Poles and potential conscription into the German Army.

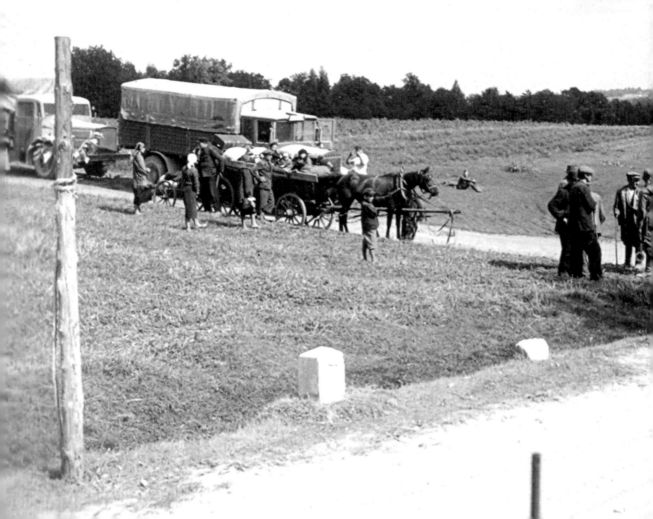

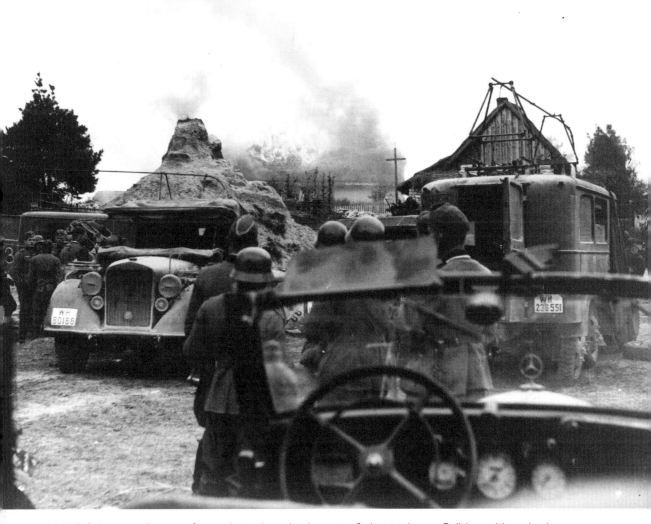

A brief stop on the way forward, to view the impact of air attacks on Polish positions in the distance. Once the fortified positions around the Mlawa area had been overcome the Poles in the region, under Lieutenant General Przedrzymirski, began withdrawing towards Modlin. The retreat took place in daylight, exposing them to concentrated air attacks by the German air force. Suddenly, on 5 September 1939 the pressure on the retreating Polish units eased, as the Germans moved further to the east, to cross the River Narew close to Pultusk and Rozan behind Warsaw.

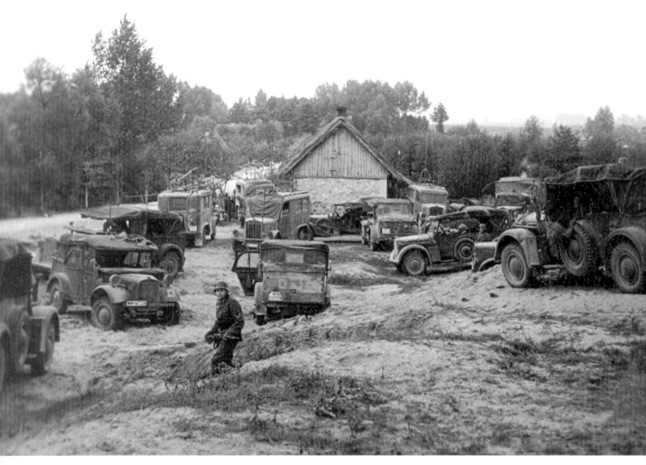

A fascinating selection of German soft skin vehicles are shown in this photograph. Note how closely they have been parked; a testament to the fact that by the second day of the invasion the *Luftwaffe* had gained complete air superiority over Poland. The coordinated use of ground forces and supporting air assets were a key to unlocking the defences of not only Poland, but also France and the Low Countries in 1940 and the early spectacular successes in Russia in 1941.

The sheer speed of the German advance in Poland had caught the Polish command entirely unprepared. By 5 September it was clear that the bulk of the Polish forces would have to fall back to the Vistula line, otherwise they would be cut off and defeated in detail. As the Polish units began to fall back the Germans simply took advantage of the gaps between large Polish concentrations of troops. Panzer and motorised units forged ahead, virtually ignoring their flanks. They simply overran partially defended areas and bypassed strongly held positions. The Germans knew that the Vistula was not fortified and at this stage there were insufficient Polish troops in position to hold it, so the gamble was taken to spread forces on a wide front, simply to get there first.

German troops in a Polish town; they appear to be watching as the Polish civilians evacuate their homes and businesses. Mechanised and mobile German units forged ahead and they were followed by the bulk of the infantry. Soon this situation began to cause problems for the Germans in terms of supply; the armoured columns were beginning to outstrip their fuel reserves. The Germans pressed on towards the Vistula, with the Polish troops retreating towards the bridges. What the Germans did not know was that two Polish armies, amounting to some ten infantry divisions and two and a half cavalry brigades, were retreating in good order. The Poznan Army was to the north of the River Bzura and the Germans thought that it was somewhere near Warsaw. The Pomorze Army was also still largely intact. Nonetheless, the Poles were spread out along a 200-mile front and the Germans were closer to Warsaw than the bulk of the Polish armies. On average, the Polish armies were up to 125 miles from Warsaw and the lead elements of the Germans just 75 miles away from the city.

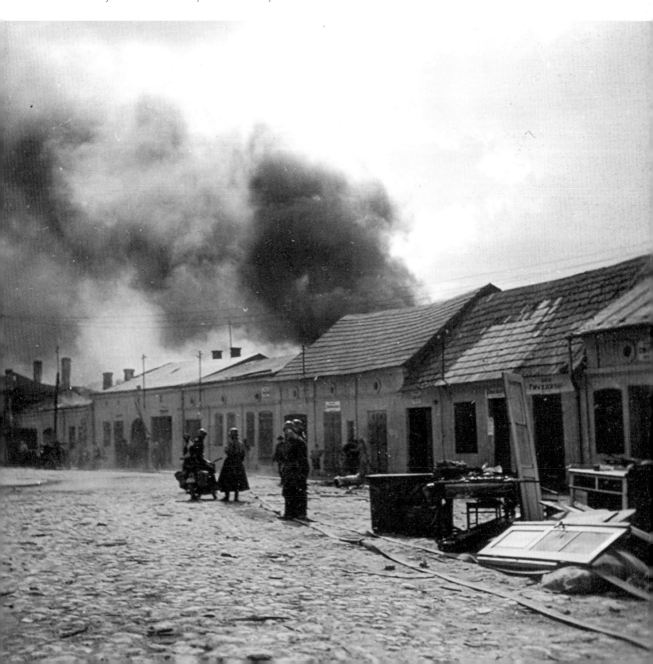

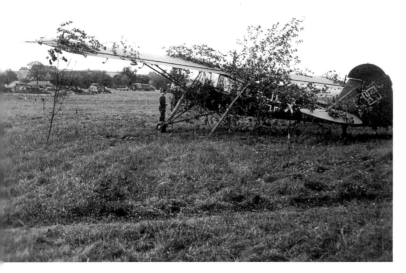

A camouflaged Fieseler Storch, and in the background the vehicles of the signals unit can also be seen. The Storch was designed by Gerhard Fieseler who was a fighter pilot in the First World War and credited with twenty-two victories. In the inter-war years he was an aerobatic pilot. He won the World Aerobatic Championship in 1934, flying a biplane that had been built and designed by his own company. Fieseler's company built trainers and fighters for the *Luftwaffe*.

What was particularly impressive about the Storch was the fact that although it could fly at a top speed of 109 mph, it could also fly as slowly as 32 mph. It could take off into light wind in less than 150 ft and land in 50 to 60 ft. This made it an ideal aircraft for liaison and reconnaissance. In fact, in Belgium and France in 1940 they were even used as ambulances and rescue aircraft. On several occasions they picked up downed air crew, or wounded infantrymen under heavy enemy fire.

One of the signal unit's drivers proudly displays his impressive collection of impromptu weapons and equipment, stuffed into the door pocket of his vehicle. Hanging from one of the door handles is the iconic Luger, a semi-automatic pistol. It was a common side arm that was used in the German Army in both world wars, although in 1938 the Walther P38 started to replace it. The Luger was officially the Pistole Parabellum 1908, or P08. It had been originally patented by Georg J Luger in 1898 and production had begun in 1900. The Luger was a fairly complicated pistol, which required precision manufacturing. It was a complex, large, powerful and comparatively expensive weapon. Eventually, more reliable and cheaper pistols replaced it. The firing mechanism was particularly prone to failure if the weapon was not meticulously cleaned.

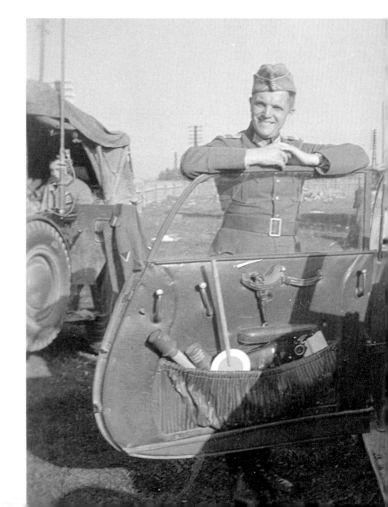

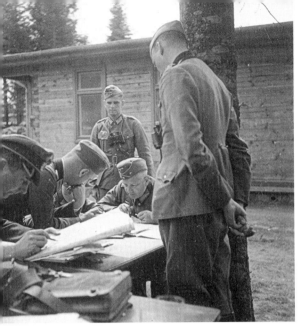

Map checking in the field, as the signal unit plots its position and its direction of march. Two of the men have standard German 6 x 30 binoculars. Each set of binoculars would have a three-letter code, which was engraved, to identify the factory in which it had been made. More powerful binoculars would be used by specialists and there was enormous variation in the types used, such as those used by tank units or in the *Kriegsmarine*. These particular glasses shown in this photograph are the standard Dienstglas, or service binoculars.

An interesting photograph, which amply illustrates that even in field conditions and on campaign, a unit would still have to provide a mass of information to division, who in turn would have to pass this onto corps headquarters. This soldier is using an abacus to make his calculations. From what little can be seen of his insignia, this individual appears to have sergeants' shoulder straps on his tunic. There would be a considerable amount of paperwork to complete. In this campaign a German signal battalion would have twice as many vehicles as an entire Polish infantry division. An enormous amount of the Polish Army moved on foot or on horseback. Not only were the Germans better equipped in terms of vehicles, but they also used the most modern communications equipment. This was something that the Poles also lacked, even at the highest command level. The German signals battalion would have a wireless company, a telephone construction and laying company and a support column.

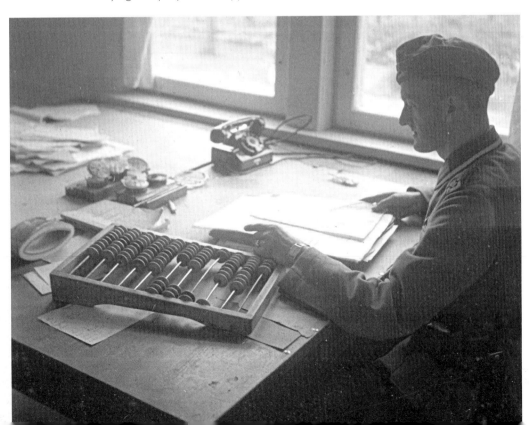

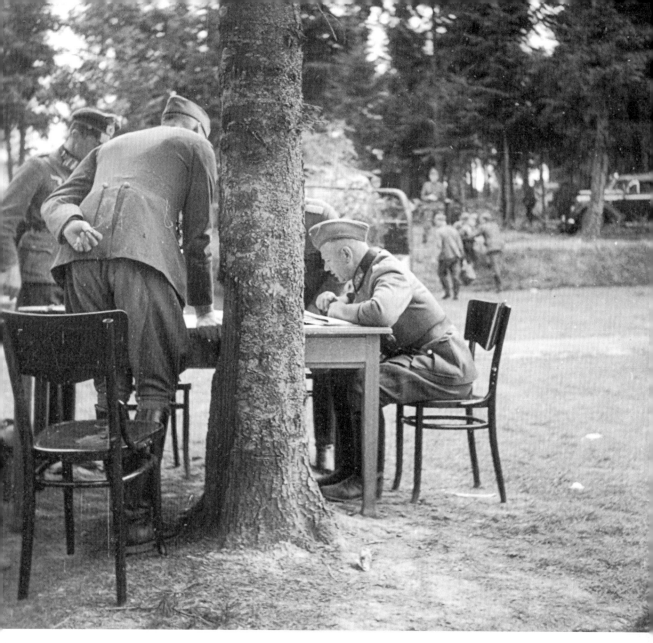

Checking maps and movement orders is the topic of this photograph. Although we cannot tell the rank of these officers, they are largely wearing M1935 field caps. The race to the Vistula saw the Germans exerting enormous pressure on the flanks of the Polish front. The German XIV Army made concerted attacks against Polish forces around Kraków and forced them across the Dunajec River. German armour poured into the gap that was made when the Poles began retreating towards the San River, before the Polish forces around Kraków had managed to cross the Dunajec River. To the north, the German III Army attacked the Polish reserve group, Wyszków, concentrated in the Rozan area. Due to confusion in orders the Poles evacuated Rozan and the Germans achieved a crossing there. This allowed them to cut off the Polish troops of the Narew group from the Modlin Army. No orders arrived for the Narew group and they remained cut off and in a precarious situation.

Vehicles of the signals unit are parked along a roadside here, allowing access for other motorised units to overtake them. By 6 September 1939 Polish troops had been ordered to withdraw to the Narew-Vistula-San line, but by the following evening it was clear that the Narew line could not be held. Consequently, the northern flank of the Polish defences withdrew to the Bug River. It was also apparent that the Narew line in the north and the San River line in the south had also been compromised, as German armour had reached the crossings. There was a glimmer of hope as the German armour and motorised units had now penetrated so deeply into Polish territory that they were virtually out of fuel. They were also in a relatively precarious situation, lacking infantry support.

Lieutenant General Kutrzeba made a third proposal for a counter-attack against the German flank on 8 September and this time it was approved. The Poznan Army struck from the Bzura River, heading south-east. The Pomorze Army covered its east wing. The attack got underway on 9 September. The Germans were either blissfully unaware of it or simply ignored it, as German troops continued to press towards the River Vistula, notably the 6th Army, under General Blaskowitz. By the morning of 10 September these German troops had been recalled to hold the line around the Bzura River.

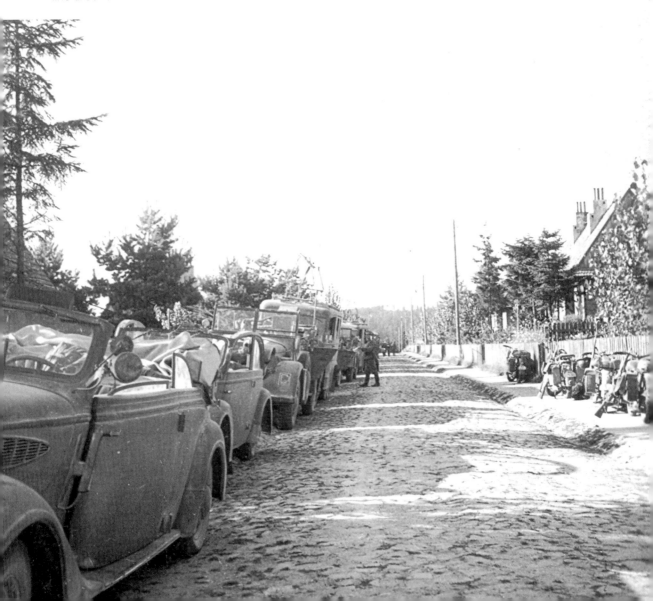

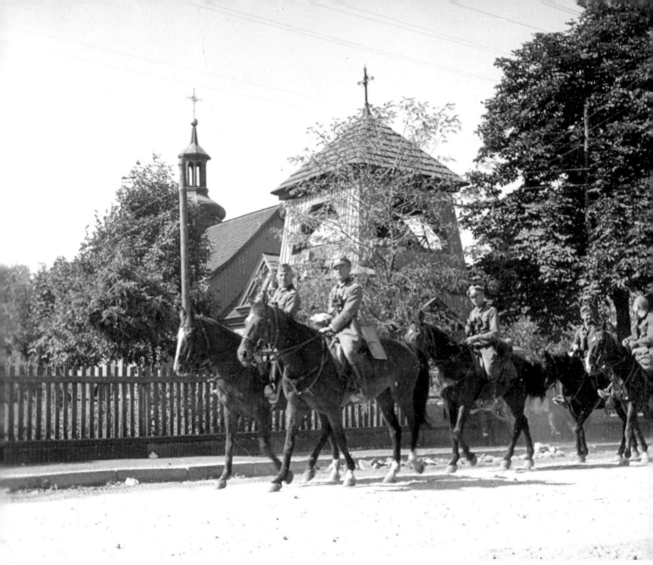

German cavalry move through a Polish town. In the invasion of Poland the Germans deployed eleven cavalry brigades. Each of the brigades had up to four cavalry regiments, supported by artillery, armour and an infantry battalion. It is difficult to know precisely to which unit these German cavalry belonged, particularly because every infantry division deployed a cavalry unit in the reconnaissance role.

The 1st Cavalry Brigade had two cavalry regiments and one partly mechanised cavalry regiment. It also had a horse artillery battalion, a mechanised reconnaissance battalion and a bicycle battalion. It mustered 6,200 men and 4,200 horses. The brigade operated under the 3rd Army and took part in the crossings of the Narew River and later in the crossing of the Bug River. It was to the east of Warsaw on the twelfth day of the invasion and it was part of the enveloping movement against the Polish capital. In many respects it operated precisely in the role of traditional cavalry. After the Polish campaign the brigade was expanded to become the 1st Cavalry Division. During the French campaign in May 1940 it travelled between forty-five and sixty miles per day and was instrumental in isolating huge numbers of demoralised French troops. Later the division would operate on the Russian front, by which time it had been expanded to six regiments. The division was ultimately withdrawn and sent to occupied France, where it would become the 24th Panzer Division, after conversion to a mechanised unit.

An impromptu opportunity to do some running repairs on the vehicles and on personal equipment in the field. In the foreground, on the right, is a German Zundapp motorcycle. Zundapp motorcycles had been constructed since 1921, although heavier motorcycles such as these went into production from around 1933. By 1938 some 200,000 motorcycles had been produced in Germany. Zundapp was one of the many motorcycle manufacturers, including BMW, that contributed to this enormous number. Many of the Zundapps were built exclusively for the Army and over 18,000 sidecar rigs were also produced. The men riding these machines wore a distinctive M1934 protective coat. It was vulcanised, rubberised and watertight. The coat could be snapped around the legs and the men would also wear goggles, pullovers, gloves and gas masks. Note that the motorcycle rider has also placed his rifle against his machine.

The soldier in the left foreground is cleaning his pair of German leather 'jackboots'. These were combat boots that rose to mid-calf, with a leather sole with hobnails and heel irons.

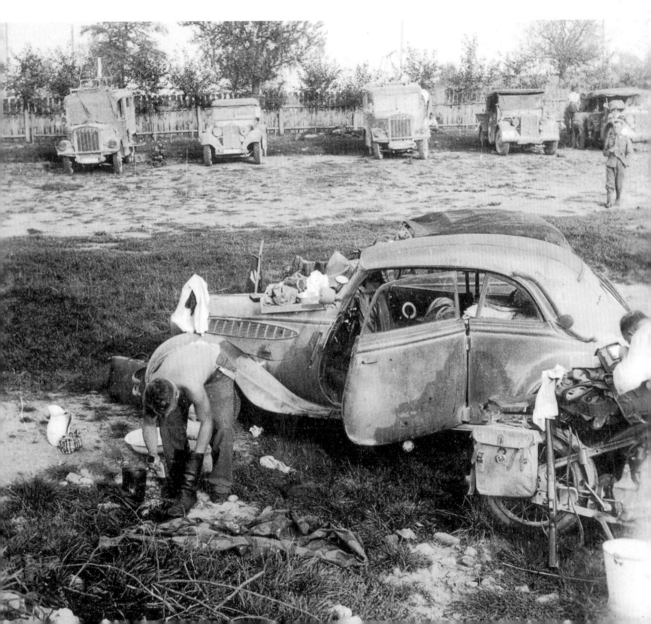

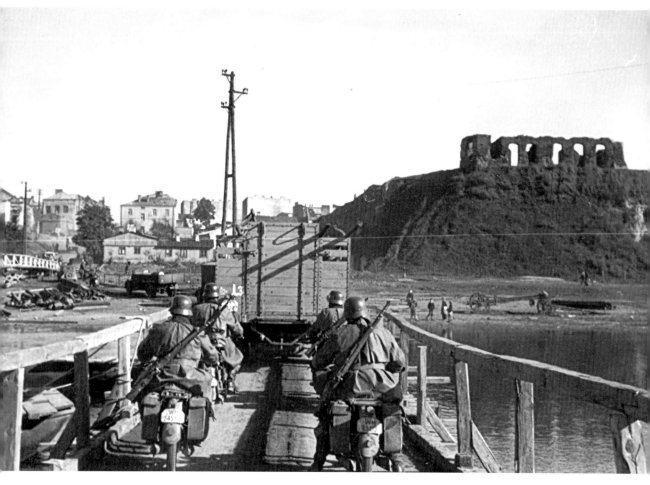

This shows a relatively peaceful crossing of a Polish river by lead elements of the signals battalion. It has not been possible to identify this particular crossing, as it may be situated along the Vistula, Narew or Bug Rivers. Not all of the river crossings were as easy as this one appears to have been and where possible the Polish troops feverishly resisted the attempts of the Germans to outflank them by holding crossings until the last minute before destroying them.

On the night of 10/11 September three German divisions of the 10th Army were directed towards Bzura. This would be a major engagement, with the first phase lasting for three days, from 9 to 12 September. The German 30th Infantry Division, which was covering the Bzura on a wide front, was shattered and pushed back when three Polish divisions, covered by cavalry brigades, attacked it.

By 12 September it had become clear to Lieutenant General Kutrzeba that if he continued to push the Germans then he risked being cut off from Warsaw, as the Lodz Army was already retreating towards Modlin. He could expect no help from them and Kutrzeba regrouped his troops, readying himself to move east and if necessary fight through German lines towards the capital.

Captured Polish prisoners; these prisoners may well be members of the Polish 20th Infantry Regiment. Clearly, whilst they could hold a position, even against heavy opposition and mechanised units, it was very much a different matter when it came to falling back, where they could easily be overtaken and surrounded. The men wear M1936 tunics and M1936 trousers and they are also wearing M1937 caps.

The men would also be issued with a bread bag, gas mask, leather belt, a pair of ammunition pouches, a universal bayonet frog, a rifle with sling, a bayonet, a mess kit, a canteen, a cup, a fork and spoon combination, a rain poncho and ankle boots. They would also tend to have a backpack, which would have a prescribed packing method, along with a blanket in a khaki material.

Although the photograph does not show this too well, the colour of their uniform was markedly lighter than that of the German soldiers. This may imply that the men were civil defence troops or reservists, rather than front-line infantry.

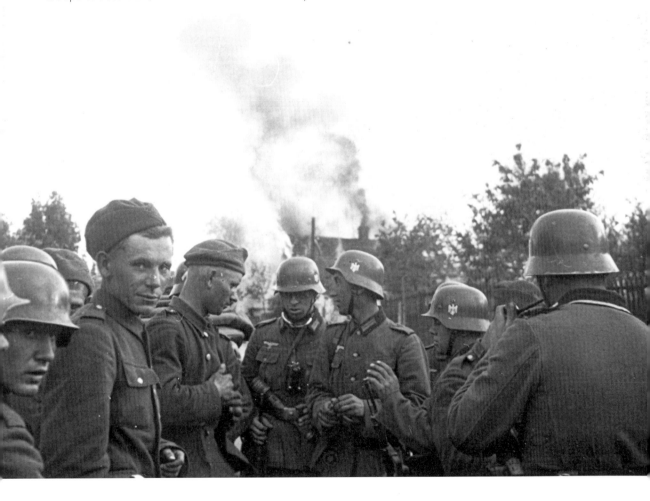

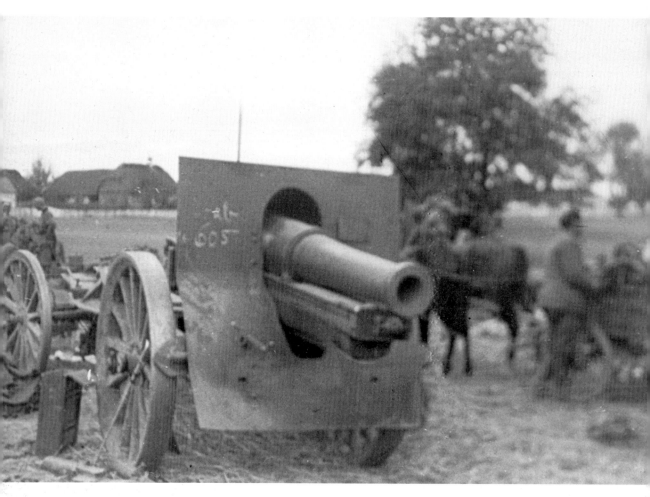

Despite the comparatively high mechanisation of the German Army compared with their Polish opponents, the Germans were still heavily reliant on horse-drawn transport and artillery. In fact, throughout the war the Germans would continue to use horse-drawn transport such as this, even into the latter months in 1945.

The fighting around the Bzura River entered its second phase on 13 September, with the German reserves arriving and two divisions of Polish troops covering the regrouping of Polish forces in the area by launching a counter-attack. The two Polish divisions from the Pomorze Army managed to halt and in places repulse two German divisions of the 10th Army, which had just arrived.

Elsewhere, matters were not that bright for the Polish forces, as at 0700 hours on 9 September the 4th Panzer Division had launched its first assault against Warsaw from the south-west. The men were supported by artillery, such as this featured in the photograph. The German tanks reached the streets of Warsaw but were met by stubborn resistance, both civilian and from the troops under Major General Czuma.

German troops are busy at work mending a wrecked bridge in this photograph. Such was the enormous confusion, chaos and destruction in Poland that sometimes the Polish defenders found themselves fighting for bridges that were already destroyed. Elements of the 20th Infantry Regiment fell back towards the Dunajec River on 7 September, in a desperate attempt to reach the bridge at Biskupice Radlowskie before the Germans reached it. Over the course of the day the Polish regiment lost 750 men in the action, a third of whom were killed. Polish sappers had already blown up the bridge and even attempts to hold the river line came to nothing, as the Germans were right behind them. Inevitably, such as in this example, sections of Polish regiments were cut off and there was extensive straggling. The 20th Regiment was down to about 60 per cent strength by the time it had broken off from the Germans and had a chance to regroup, only a day or two later.

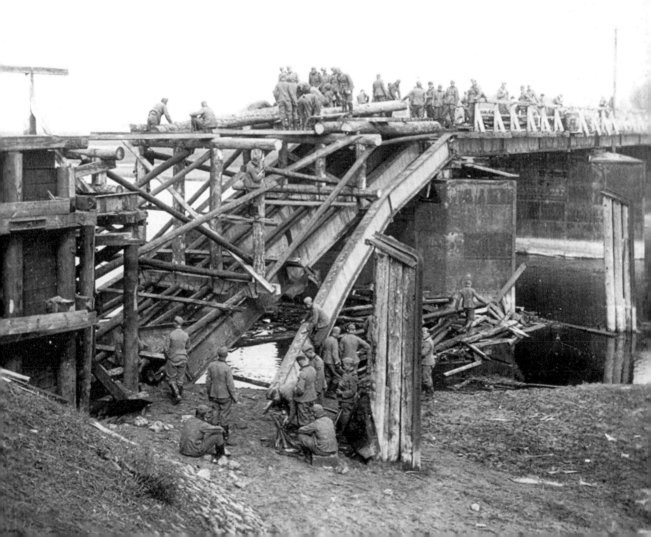

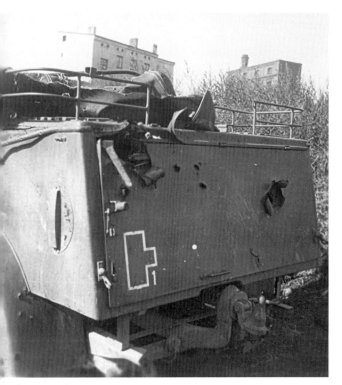

This is the rear of one of the signal unit's trucks. Note the battle scars, which appear to be a combination of rifle fire and small calibre shells. Some three hours after the 4th Panzer Division launched its assault on Warsaw it was clear that the Polish resistance was far stiffer than had been anticipated. One of the panzer regiments of the division had been reduced from 120 tanks to fifty-seven. The division was pulled back to its start positions and, incensed by the withdrawal, XVI Corps ordered the division to renew its assault. The divisional commander told the corps commander that this was impossible if the division was to remain an operational unit.

Meanwhile, the Germans began crossing the Vistula River in strength between Warsaw and Sandomierz, with the target of Lublin. Large concentrations of Polish troops were still trying to break through to the east bank of the Vistula River. The 1st Panzer Division had managed to establish a bridgehead on the eastern bank, at Gora Kalwaria, and from here it came under constant attack from Polish troops in the Warsaw area.

This is a view through the windscreen of one of the signal battalion's vehicles as it passes a halted column of German artillery. Note that the SdKfz 7 is being used as a prime mover, as can be seen by the two vehicles parked on the right-hand side of the road. The artillery pieces appear to be German divisional level heavy howitzers. They were based on the First World War vintage 15-cm howitzers and were produced between 1933 and 1945. The gun came into service in May 1935 and by the outbreak of the war the German Army had over 1,300 of them in service. They had a maximum range of 13,250 m and a rate of fire of four per minute. It was the first artillery weapon to be equipped with rocket-assisted ammunition. This gave the shell greater speed and range. Ultimately, modified versions of this weapon were fitted to a motorised chassis to become the Hummel, or 'bumble bee', self-propelled artillery.

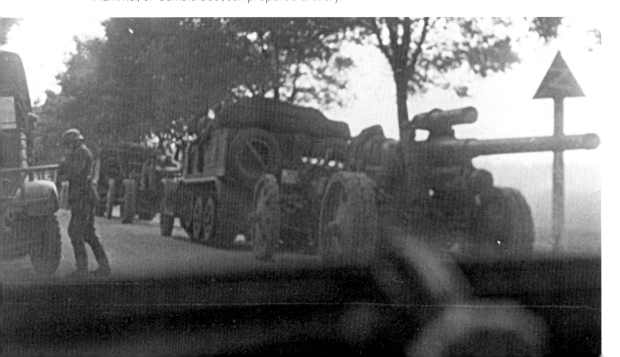

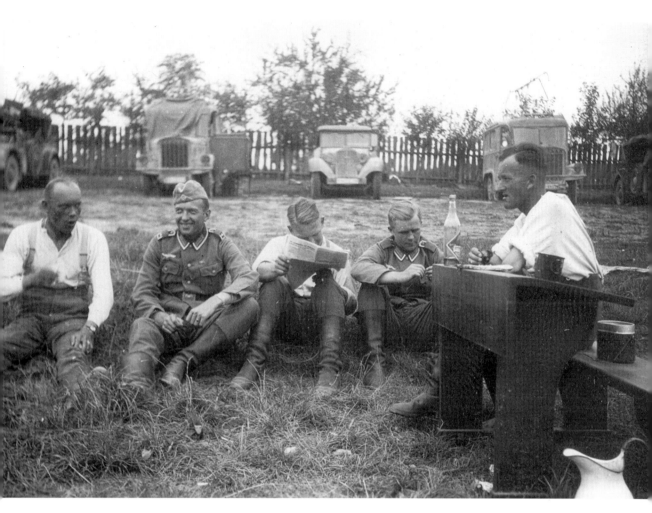

This shows members of the signal battalion taking a break in the field, as the offensive continues towards its inevitable conclusion. In the southern sector of the campaign the German 5th Panzer Division had destroyed the bridge south of Sandomierz, but could make no further progress. The men wear their field caps of field grey. The man on the left of the photograph has full-length trousers in the same field grey as the field uniform coat. Suspenders are used with these types of trousers, with two sets of suspender buttons sewn in place. Many of the trousers had a reinforced seat and semi-breech legs so that the leg ends could fit into the marching boot. There were two slanted front pockets, a buttoned hip pocket and a watch pocket with a ring. The trousers could be tightened at the waist by using two tapes and a metal buckle at the rear.

This photograph shows a pair of Storches parked under shade in a Polish field. Of the 2,000 or so aircraft that were used by the Germans against Poland in 1939 some 258 were lost. An estimated 230 of these were destroyed in action. An additional 263 were damaged, although around 40 per cent of these were later repaired. The wings of the aircraft could be folded back along the fuselage so that it could be carried on a trailer, or even towed. The long legs had oil and spring shock absorbers, which meant that the aircraft could set down almost anywhere. It was the long appearance of the legs that gave it the aircraft its nickname.

The Storch will probably remain most famous for the role it played in the rescue of the deposed dictator Benito Mussolini from the Campo Imperatore Hotel at Gran Sasso. Ninety German paratroopers landed on the peak of the mountain and Walter Gerlach flew in, in a Storch, and landed in just 100 ft. Mussolini was taken on board and it took off again in less than 250 ft.

The men of the unit roast a liberated Polish fowl over an open fire here. In the north, where the 1st Infantry Division was operating, the majority of the Polish Army was retreating towards the Vistula. However, the Polish 3rd, 12th and 36th Divisions were cut off at Ilza and destroyed. Most of the other divisions made it back to the Vistula, where they crossed and rapidly began to be reorganised into new divisions. More Polish units headed for Warsaw, becoming involved in fighting around the city. They then withdrew to the north. As the Germans overtook isolated Polish units some of them still continued to fight. But the main action was still taking place around Bzura. The Germans were pushing any armoured or motorised troops to bring them into the battle. This meant that the pressure against the Vistula line had slackened. The Polish troops around the Narew River and around Modlin were desperately trying to avoid being entirely cut off and they began to withdraw over the night of 9/10 September. The Narew group counter-attacked around the fork of the Bug and Narew Rivers and inflicted heavy casualties on the Kempf Panzer unit. In the nick of time the German XIX Corps appeared and after three days of vicious fighting the Polish infantry were wiped out. At the same time the Polish units of the Modlin Army were fighting with the German 3rd Army and had suffered heavy losses. They managed, however, to avoid a major confrontation with German armour and were retreating towards the Wlodawa and Chelm area.

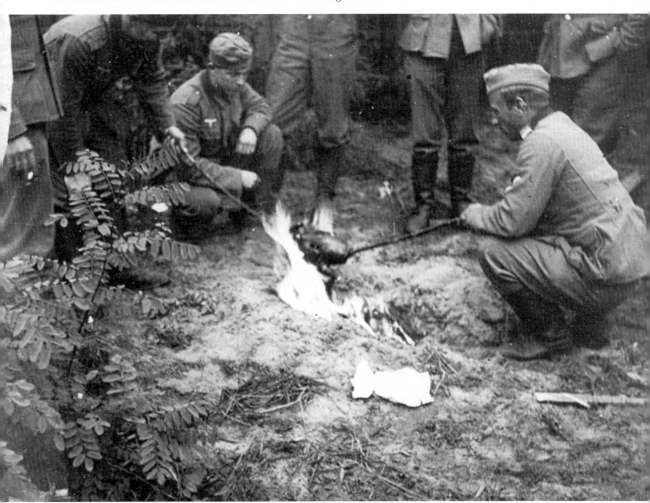

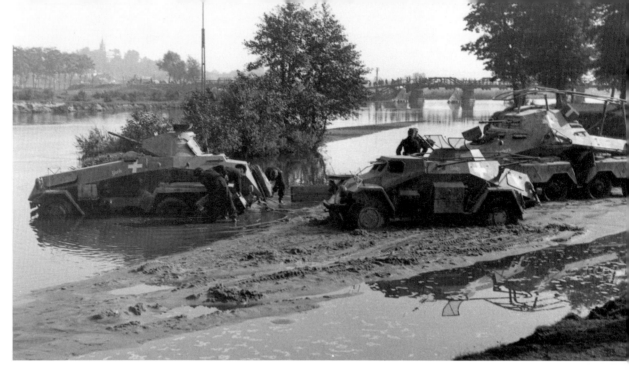

An assortment of German armoured cars attempt a crossing of a river and become bogged down in the mud. There are three different types of German armoured cars featured in this photograph. The lead vehicle is an SdKfz 231 and the rear vehicle is an SdKfz 232; both of them were six-wheeled vehicles. The four-wheeled vehicle in the centre is an SdKfz 221. Prior to the development of the SdKfz 221 and its successors, the German Army had been using the Kfz 13 which was an Adler-built armoured car.

The re-armament push in the mid to late 1930s brought the desire to create a light armoured reconnaissance car with a single machine gun (later a 20-mm tank gun) as well as a radio car for communications and command. The solutions included both the SdKfz 221 and later the SdKfz 222. Production of the SdKfz 221 began in 1936 and until 1938 it was produced on a chassis with a 75 hp engine. Between 1939 and 1942, when production ceased, the engine had been upgraded to 81 hp. The vehicle was to stay in service for the remainder of the war. It had fully independent suspension, optional four-wheel drive steering and a self-locking differential, which allowed the vehicle to receive the correct amount of power on any type of ground. In the case of the SdKfz 221, the turret was a seven-sided open-topped design. It was decided in 1942 that the development of four-wheeler armoured cars would be discontinued in favour of the bigger eight-wheelers.

Just as the SdKfz 221 had replaced the Kfz 13, it, in turn, would fall into disfavour. The vehicle had proved itself to have a good cross-country performance with a relatively reasonable armour protection and initially the SdKfz 221 was armed only with an MG 34 machine gun. The later models and some of the earlier vehicles were refitted with a 20-mm tapered bore anti-tank gun that was set high in the turret. This conversion was rather haphazard as by the time it was considered that this step was necessary, light armoured cars were becoming less important and the majority of the available 20-mm guns were being fitted into half-tracks. The gun itself allowed the SdKfz 221 to be useful for anti-aircraft combat. But in close combat conditions, as the turret had no roof, the crews initially had very little protection. This problem led to a series of wired grills being fitted around the top of the turret and its sides, which were hinged primarily as a protection against grenades.

The decreasing numbers of SdKfz 221s were still used by a variety of different units such as tank battalions who used them for liaison work and others were deployed in motorised reconnaissance units.

This is a burnt out Polish aircraft. The Polish Air Force was outnumbered by around five to one and the vast majority of their losses were due to combat. It has been estimated that 187 were lost in air-to-air combat, around thirty to German ground fire, thirty-three to friendly fire, just over fifty were destroyed on the ground, and 140 were badly damaged either by attack or poor landings and subsequently written off. Nearly 100 aircraft, mostly fighters, managed to escape to Romania.

The Polish Air Force was mobilised and ready for the German offensive and the front-line aircraft, around 313 of them, had been well dispersed to satellite fields the day before the invasion. The only airfield that was attacked in strength on the first day was near Kraków. The Germans destroyed around twenty-eight unserviceable aircraft. The most successful ground attack by German aircraft took place on 14 and 15 September when seventeen light scout bombers were destroyed at the Hutniki airfield.

It is difficult to be precise about how many German aircraft were shot down by the Polish Air Force, as the Polish criteria for a confirmed kill was far more exacting than other nations. The Poles claimed to have shot down 220 German aircraft; of this total 133 were air-to-air combat kills and eighty-seven from ground-to-air fire. The German records suggest that the total was in excess of 285.

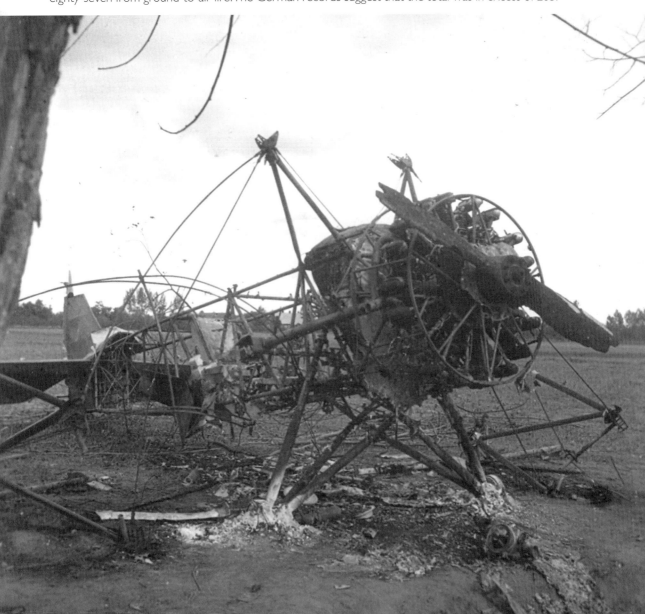

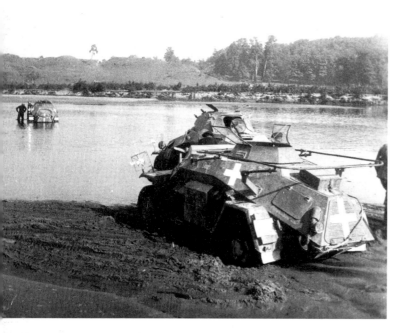

The German armoured cars make a little more headway in crossing the shallow river. By 15 September the bulk of German operations were focused on the centre of Poland. They were aiming to stop Polish troops around the Bzura River from breaking through to Warsaw. The primary objective was to destroy the Bzura pocket. Warsaw would have to wait. The Germans demanded Polish surrender, but the Poles rejected the demand. Warsaw continued to be under heavy artillery fire, but the main action was in the continuing battle of the Bzura. It was now entering its final phase and the Germans threw everything that they had into it. The vast majority of the Polish troops in the pocket were destroyed. Some remnants of the Polish 15th and 25th Divisions and two Polish brigades managed to make it through to Warsaw. The Germans had deployed twenty-nine divisions in the battle of the Bzura.

A German military hospital, set up in the grounds of a Polish building. There has been considerable debate about the losses sustained by the Germans during the Polish campaign. A study published in 2000 by the German Armed Forces Military History Research Office estimated that the total number of German dead during September 1939 amounted to around 15,000. Statistics collected during the war suggested 10,570 killed in action, 30,322 wounded and 3,400 missing in action. This was out of a total force of around 1.25 million men; some forty-four infantry and fourteen panzer divisions. The Polish government estimated in 1947 that their losses had been 66,300 killed and 133,700 wounded. This was out of a total of 800,000 men, consisting of forty infantry divisions and sixteen brigades. A later estimate, in 1995, included Polish officers that had been massacred by the Soviets at Katyn (up to 19,000). This revised estimate suggested up to 97,000 killed and 130,000 wounded.

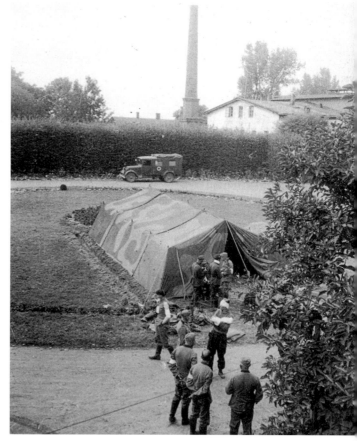

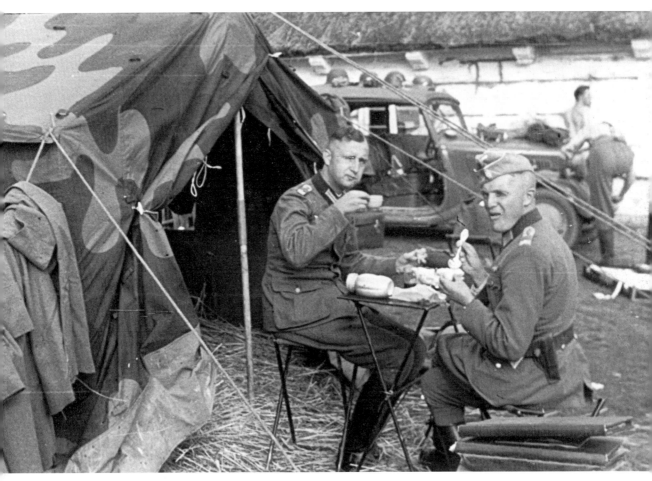

Men of the signals battalion are taking a food break. Note the line of German helmets placed on top of the vehicle to the rear of the photograph. By mid-September the German XIX Corps had encountered newly formed Polish units in the Polesie district. They were putting up a stiff fight and the German losses were mounting. The German armour still tried to break through, but lacking infantry support and suffering from relatively poor communications, losses began to mount. Between 15 and 18 September Polish Lieutenant General Dab-Biernacki established a new set of defensive positions in the Lublin and Chelm area. He had scraped together the remnants of several army groups and other scattered units, up to a strength of around ten infantry divisions. They were ordered to move to the area to the east of Lwow. Further to the south, German forces were being held up by Polish troops between the lower San River and Tomaszow Lubelski.

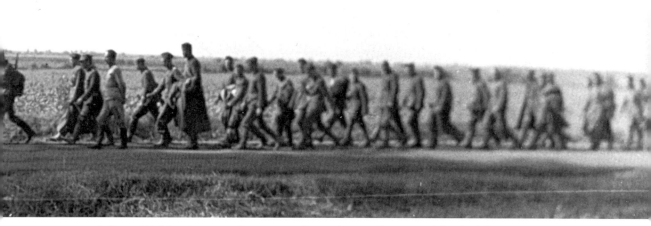

A line of Polish prisoners of war; note that only one German soldier is visible in the photograph, leading the column. Many of the estimated 400,000 Polish prisoners of war were confined in forced labour camps. Across Poland it has been estimated the Germans set up around 440 of these camps and ultimately 1.5 million Poles were set to hard labour. In February 1940 the German authorities gave the Red Cross lists of Polish prisoners of war that they were holding. The information abruptly stopped until 1943, when new lists only contained the names of officers.

The vast majority of other ranks became civilian workers, in defiance of international agreements, and therefore the Red Cross lost track of these prisoners of war. Huge numbers of the Polish non-officer prisoners were sent to carry out forced labour in Germany. Large numbers of them also found themselves used as poorly paid civilian workers; they were subject to curfew, had no holidays, worked seven days a week and could not have any possessions or money.

An unidentified column of troops, possibly prisoners, are being led by a mounted German officer. The fighting in the south-east of Poland continued with as great intensity as before. A Polish attempt to break through to the south-east by the 21st Infantry Division failed when it was blocked by the German 45th Division. General Sosnkowski threw the Polish 49th Infantry Regiment at the SS Standarte Germania Regiment and caught them by surprise. The Germans lost most of their heavy equipment, including their howitzers and anti-aircraft guns, and most of their vehicles were also destroyed. This action took place on 15 to 16 September around the village of Myslowice, to the west of Lwow. News of this victory quickly spread and although the Poles exaggerated what had happened it helped boost the morale of other Polish units. In the meantime, the Germans were still trying to encircle Lwow.

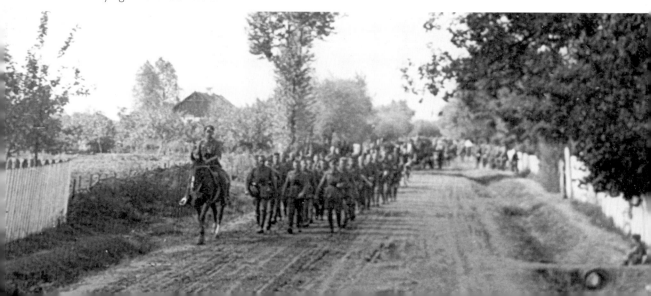

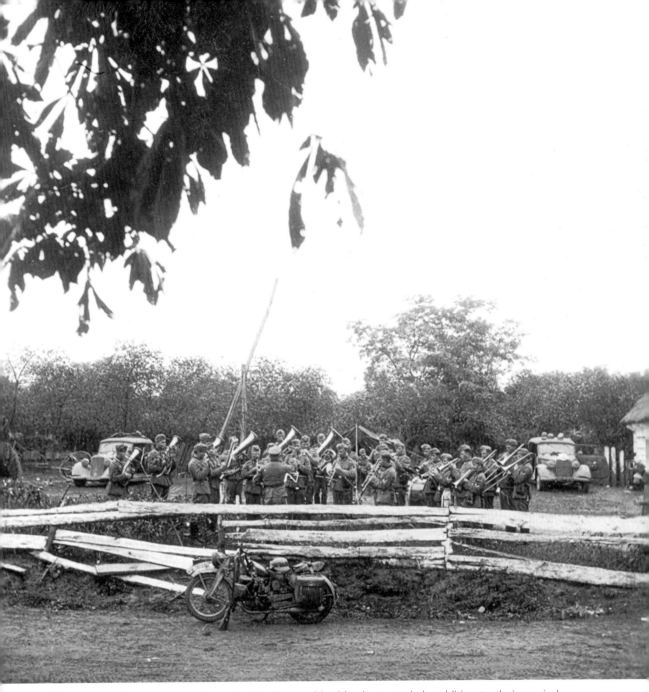

A German military band performs beside the road in this photograph. In addition to their musical instruments German bandsmen could be identified as they wore swallows' nests (*schwalbennester*). These were matching pairs of wings, worn on each shoulder of their military tunics. They were worn on service and uniform tunics, not on great coats. Normal day-to-day military service did not require them to wear the nests. Drum and fife musicians wore dull grey braiding on a backing of cloth. Regimental bandsmen and trumpeters had aluminium braiding with a backing of cloth. Battalion buglers also had bright aluminium braiding, but had a deep fringe on the nest. The nests were removable and held in position by five metal hooks. These clipped into five eyelets, stitched around both of the shoulder seams.

These are the remains of a wrecked Polish bridge, which has been partially repaired to allow pedestrian traffic only. Not all of the Polish bridges were destroyed by the Germans; many of the river crossings were in fact destroyed, particularly along the River Vistula, by Polish sappers. A prime example is the bridge that crosses the River Vistula at Tczew in northern Poland. The bridge of Tczew had been rigged for explosion by Polish sappers and German aircraft attacked the sapper installations to prevent them from being blown up before dawn on 1 September 1939.

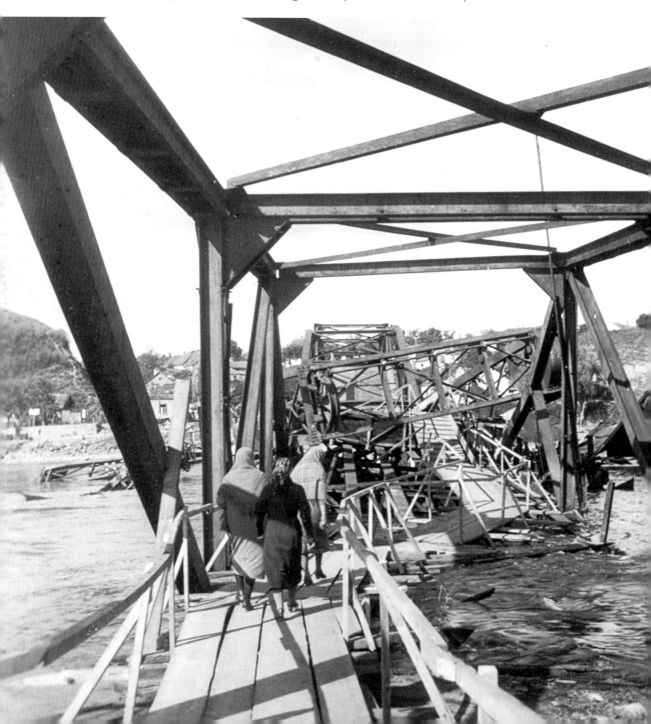

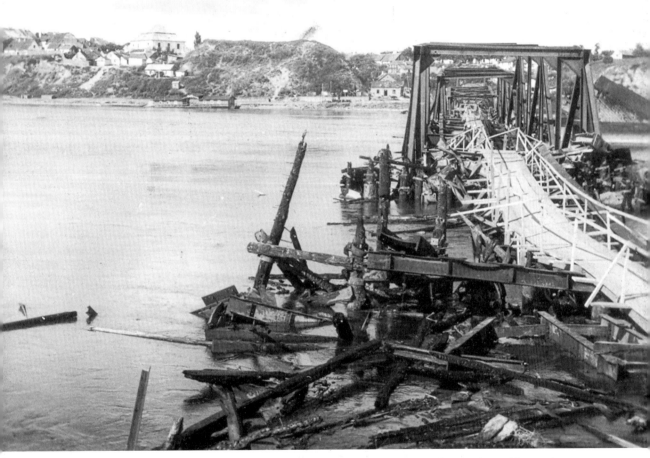

This is a more extensive view of the destruction of the bridge. Destruction such as this amply illustrates the fact that the Polish campaign was an example of total war. Polish civilian casualties were high throughout the actual invasion and afterwards. German aircraft attacked columns of refugees to block roads, disrupt communication and deal blows to Polish morale. Ultimately some six million Poles, or 22 per cent of the population, would perish before the end of the war.

This is a Polish 7 TP (Tonowy Polski) light tank. In recognition of the fact that the tankettes would be inadequate for modern armoured warfare, Poland began to experiment in 1931 with variations on the Vickers-Armstrong 6-ton twin-turreted tank. By 1936, twenty-two had been constructed but the Polish 1936 Rearmament Plan called for a single-turreted light tank which would be armed with the Swedish 37-mm anti-tank gun. This would be designated the 7 TP series. The original twenty-two completed vehicles were re-designated 7 TP dw and the new version the 7 TP jw. Prototypes were completed in 1937 and by 1938 the tank was in production. Modifications were made to the prototype turrets in order to accommodate a radio and around fifty variant tanks with a diesel engine came into service before September 1939.

The 7 TP first saw action in Czechoslovakia. By the time of the Polish invasion, 179 of the 7 TPs were available, of which 114 were deployed in two tank battalions and a partially completed third. Each of these battalions had three companies of sixteen tanks and the third battalion could only deploy one company. Initially, the first battalion was deployed in the Polish Corridor but was ordered back to cover Warsaw, where it was engaged in a running battle. The second brigade, operating in Silesia, showed the true effectiveness of the 7 TP. On 4 September the battalion destroyed six German tanks and two armoured cars for the loss of one vehicle and later on the same day, knocked out eleven more German tanks for just two losses. The third battalion also fought in the defence of Warsaw and in cooperation with infantry units knocked out forty German tanks. 7 TPs were also involved in a series of counter-attacks around Warsaw, but due to heavy German pressure and numbers, suffered considerable losses.

When the Polish campaign was concluded the Germans pressed the remaining 7 TPs into service, re-designating them the PzKpfw 7 TP (P) and these were later passed on to the Romanians.

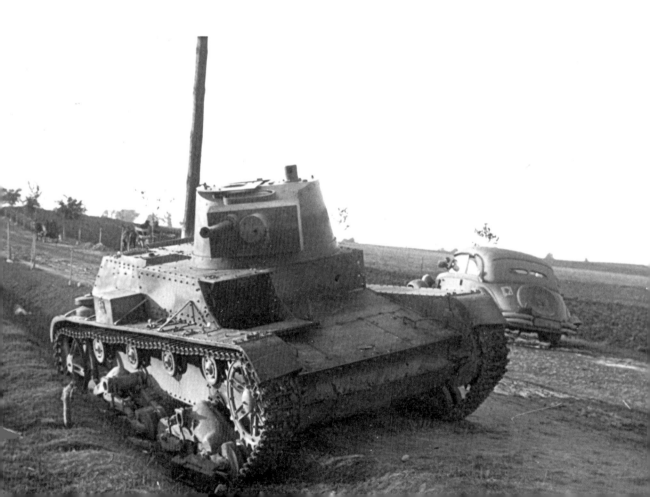

This German soldier is seen walking through a recently taken Polish city. Warsaw suffered extensively from terror bombing in 1939. In fact, by the end of the war, including the destruction that had been wrought upon the city during the Warsaw uprising in 1944, some 84 per cent of the city had been destroyed. The defence of Warsaw in 1939 had begun to reach desperate measures as early as 8 September. General Czuma had scraped together two infantry divisions, sixty-four artillery pieces and thirty-three tanks and tankettes. Troops were still moving to try to reinforce the Warsaw defence effort. By 11 September the Polish commander in chief, Marshal Rydz-Smigly, ordered the city to be defended at all costs. On the following day German troops had broken through and had begun to cut Warsaw off from the east. Polish counter-attacks failed and by 15 September the city was under siege. The Germans prepared for an all-out assault and by 22 September the last lines of communication between Warsaw and the outside world had been severed. The Germans were ready to launch their final assault on 25 September.

This is another abandoned 7 TP. This tank had proven its battle worthiness and had a respectable ratio of kills to losses against German armour, but it is a prime example of a tank that arrived too late and in insufficient numbers to make any real impact on the battlefield. The 7 TPs were invariably outnumbered and German tactics of encirclement and rapid movement cut them off from their supply bases. Proposals were in place to develop the 7 TP with heavier welded armour and for a new version which would be designated the 10 TP with a V-12 engine and Christie suspension. Prototypes were still being tested when the Germans invaded. 7TP tanks were used by the 1st and 2nd Light Tank battalions. They were also used in two improvised Warsaw defence light tank companies.

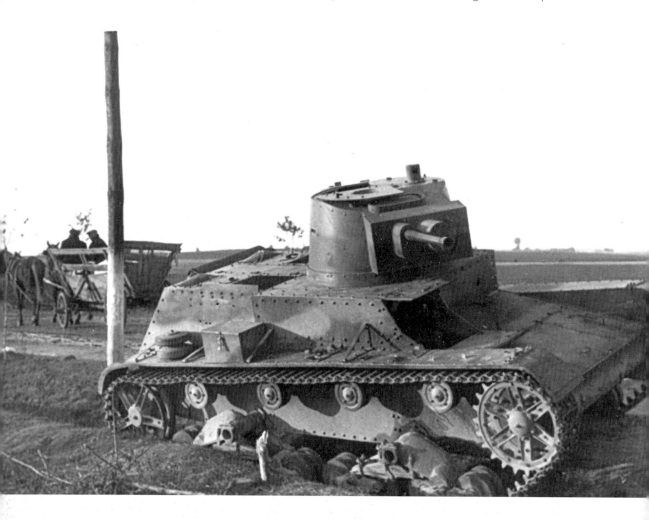

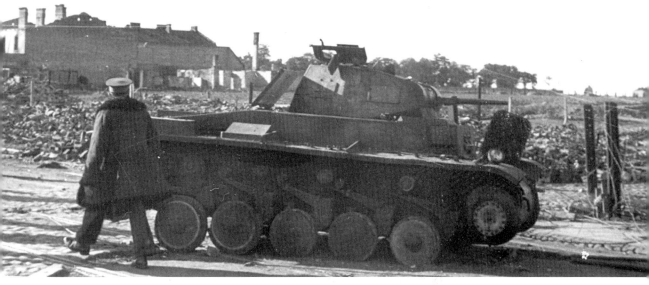

Another shot of a knocked-out tank. In the last stages of the defence of Warsaw some twenty-seven Vickers E 7TPs and French R35s, along with six tankettes, had been scraped together. The western parts of Warsaw were attacked by no fewer than five German divisions. The eastern part was attacked by four and the Germans had brought up around 150 batteries of field and heavy artillery and the *Luftwaffe* pulverised the city. The initial attack was repelled as it came in on the morning of 25 September. In fact, Polish counter-attacks managed to temporarily regain some sectors of the city. On 27 September a second assault was ordered by the Germans, but once again this was held off.

This is a derailed tram; this meant that the only viable transport in the city was horse drawn. After the German attack on 27 September 1939 General Czuma was fairly confident that he could continue to hold the city. It was not so much an issue of military capability, but the increasingly difficult plight of the civilians. The constant bombardment was inflicting heavy casualties and there was little food or medical supplies. German aircraft had destroyed the waterworks. This not only meant that there was no drinking water, but also the defenders lacked the ability to put out fires. The deputy commander of Warsaw, General Tadeusz Kutrzeba, began capitulation discussions on 26 September. It was agreed that the ceasefire would begin at 1200 hours on 27 September. By this time, of course, the Russians had crossed the border of Poland ten days before. It had taken the Poles entirely by surprise and they had moved to cut off Polish forces from Romania and Hungary.

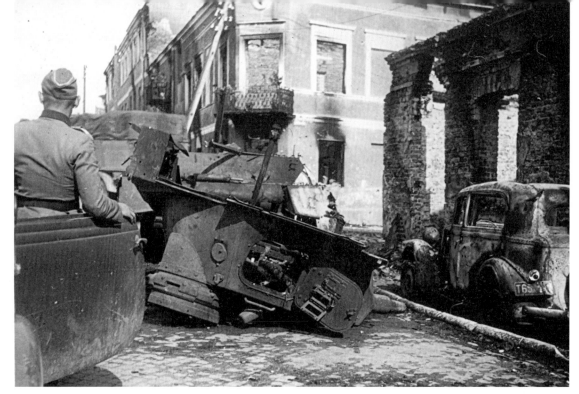

Military and civilian wreckage blocks the way as the signals battalion moves along a Polish street. On 29 September the Warsaw garrison began hiding or destroying their weapons. On the following day the Polish Army began to march into captivity. Both German and Russian troops had met on the upper Dniestr River on 20 September; however, some 30,000 Polish troops had made it to Romania, another 60,000 to Hungary and, in the north, 15,000 had crossed into Lithuania and Latvia. By 29 September most organised resistance had ended. Polish naval forces surrendered on 1 October, but a pair of Polish submarines managed to make it all the way to Great Britain.

This is a German *gefreiter*, posing alongside discarded but unused artillery shells. The defeat of the Poles, despite their bravery, had been rapid and decisive. Poland had not been supported by her allies, regardless of the fact that Britain and France had gone to war over Germany's invasion of Poland. The four-week campaign had not precisely gone to plan for the Germans. Their total military superiority in terms of equipment had saved them from some very nasty surprises.

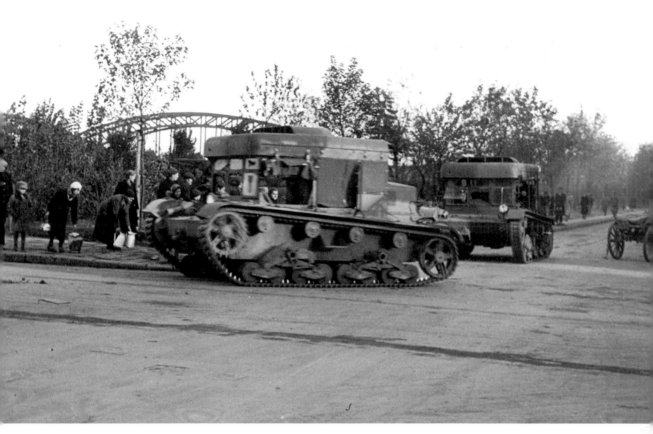

These are C7P Polish tracked artillery tractors, which effectively were based on the Vickers E. The first two prototypes were constructed in 1933 and by 1934 production had begun. The Poles ordered 350 of them, but only 151 had been constructed by the outbreak of the war. Around 108 were used as artillery tractors to tow heavy 220-mm mortars. Other tractors were attached to tank units to tow immobilised tanks and for engineering work. A number of the tractors were used during the defence of Warsaw and most of these were captured by the Germans, as these two appear to have been. The Germans used them for towing and for snow ploughs.

The shape of things to come for the residents of Polish cities: long queues for supplies, food and water. Warsaw became a battleground once again in August 1944 when the Polish Home Army rose up in anticipation of the arrival of the Russian Army, which had already penetrated Poland. The Polish resistance held out for over sixty days until they were forced to surrender on 2 October. It was another bitter blow for Warsaw and for Poland. Tens of thousands were killed and some 35 per cent of the city was levelled, block by block, by German troops. The Russians did not enter Warsaw until January 1945.

Polish civilians: note the queue on the right-hand side. The fate of many of these civilians during the five years or more occupation by the Germans was a grim one. The military commander of the city, Lieutenant-General Walerian Czuma, was taken prisoner along with his men. He was to spend the rest of the war in a prisoner of war camp. US forces liberated him from Oflaf VII-A in Murnau am Staffelsee in Germany. He joined the Free Polish in the west and after the war the Communist government in Poland took away his citizenship. He remained in Britain, living at Penley, near Wrexham, until his death in 1962.

Chapter Two

The German Medical Service in Poland

The fifteen photographs selected from an album belonging to a member of the German Medical Service illustrate not only the work and equipment of that branch of the army, but also, to some extent, the fact that they could often find themselves in relatively difficult situations. This was the case even though technically they were non-combatants. We will also see that the men had received, or were in the process of receiving, rudimentary military training.

The German system for dealing with casualties used a basic sorting principle. Men that were not seriously injured were dealt with on the spot, or just behind the lines, so that they could be returned to their units as quickly as possible. Those that were more severely wounded were given medical care as quickly as possible. The Germans often set up chains of casualty collection points to ensure the rapid rearward movement of the sick and wounded. Casualties that were unable to walk from the battlefield were evacuated by their own battalion stretcher bearers. They were taken to the battalion aid station, which would be fairly close to the front line. In effect, they would provide first aid. If necessary the man would then be passed on to the regimental aid station. Here they would be sorted into ambulatory cases and stretcher cases. Those needing to be carried would be sent to an ambulance loading post and ambulatory cases would be instructed to make their way to the rear on foot. The stretcher cases would then find themselves at the main dressing station and the walking wounded would make their way to a collecting point for the slightly wounded. These would both be controlled by the regimental medical officer.

The main dressing station would have a surgical unit and here amputations, dressings, splints, blood transfusions, sedatives and injections would all be available. After treatment they would be evacuated to the rear. The slightly wounded would be treated and then returned to combat. If necessary, they too would be evacuated to the rear.

Casualty collection points were set up at railheads and traffic centres. Mobile field hospitals would act as way stations for casualties. Field hospitals would usually be set

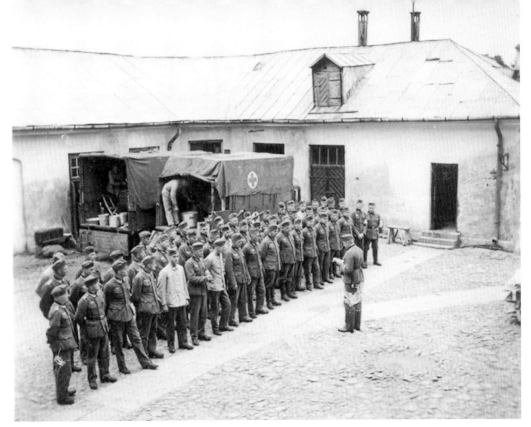

This photograph shows a German medical unit assembled for roll call. The German medical service had to rapidly change the way in which it operated as a result of mechanisation. The Polish campaign gave the medical services their first opportunity to test their new organisation. They wanted to establish the best medical supply system possible and deal with problems of transportation. In the German Army the medical services were, to some extent, embedded within each combat unit. Each soldier carried one large and one small first aid packet. They were trained to apply these dressings. Medical personnel in combat units included stretcher bearers, who had first aid training and knowledge of transporting the wounded. A non-commissioned officer or private that had some medical training was also assigned to each unit.

up in permanent buildings and have as many as 200 beds. Men that could be evacuated after treatment, either at the main dressing station or the field hospital, would then be moved to a base hospital or even a general hospital. Base hospitals usually had around 500 beds and were set up to deal with men that needed treatment for up to eight weeks. As soon as was practicable they would then be moved to reserve hospitals, or base hospitals for minor cases, so that they could convalesce. If a man was in a general hospital for more than eight weeks then he would be returned to the replacement army for reassignment.

In this collection of photographs we will see a variety of different German ambulances and trucks; even horse-drawn transport and hospital aircraft were used. The standard German ambulance would carry four stretcher cases or two stretcher cases and four sitting cases, or eight sitting cases.

The medical unit in their full parade dress prior to their deployment in Poland. The organisation of a medical detachment within a division tended to consist of two medical companies, one motorised field hospital that was capable of dealing with 200 patients and two motor ambulance trains, each of which had fifteen motor ambulances. All of these elements would be under the command of the divisional medical officer. Some of the medical companies would be horse drawn, but as in this collection of photographs we can see that they were fully motorised. In fact, for highly mobile units there would be no field hospital, but instead a third motor ambulance train.

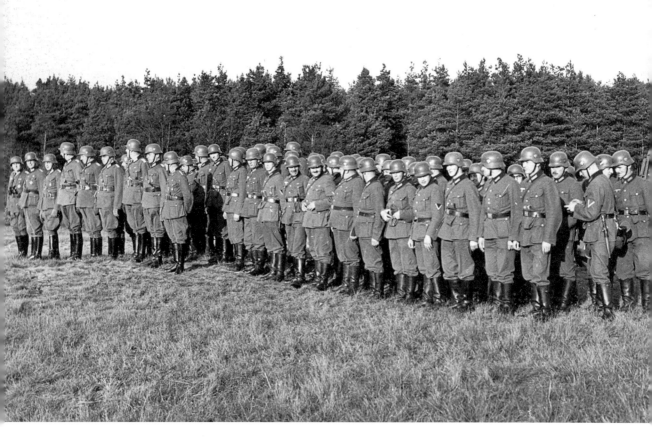

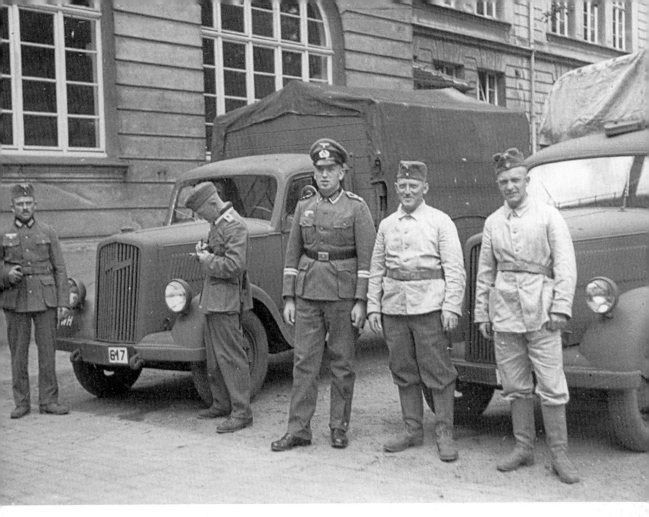

This is a mixture of officers and private soldiers from the medical unit. The two men on the right of the photograph are wearing the German Army denim fatigue uniform. These were off-white, unbleached denim uniforms that were standard issue garments to all recruits in the last few years before the outbreak of the war. The material had a fine herringbone pattern, was hardwearing and consisted of a shapeless, single-breasted jacket (*drillichrock*) and shapeless trousers (*drillichhose*). As can be seen in this photograph, the jacket is being worn correctly; closed at the neck by the top button of five detachable field grey buttons. It has a normal turn-down collar and a pair of patch pockets that do not have flaps. The trousers are made of the same material, and they have two side pockets. The idea was that the uniform would be easy to wash and could be used for a range of different fatigue duties, parade instructions, motor vehicle maintenance and weapon cleaning.

The officer in the centre of the photograph would be officially designated a *sanitat* officer and could either be a general practitioner or a specialist. The generic term for the medical personnel that included the doctors, medics, stretcher bearers and nursing staff was *sanitatstruppen*. The officer would normally carry with him a haversack with an extensive selection of surgical instruments, including probes, lancets, forceps, a wide variety of dressings and a tinplate case for tablets.

This interesting photograph, which by the date below the image indicates that it was taken at some point in August 1939, shows the men on board an ambulance wearing gasmasks. Unlike the First World War, gas was not employed in combat situations. Nonetheless, men were still trained to not only ensure that they carried their gasmasks but so that they were well aware of how to wear them and operate with them. The Germans prepared for the prospect of chemical warfare and built up stocks of gases and gas shells. Anti-gas shelters were constructed in most German cities and gasmasks were issued to civilians.

Most of the German gasmasks were of the snout variety, with a canister directly connected to the face piece. The most common types were the GM30 and GM38. They also produced three types of gasmasks for horses and one for dogs. The GM30 had four layers in field grey fabric, with a suede leather fitting band, leather chin support and plastic eye pieces. The GM38 started replacing the GM30 in 1938. It was of similar design, but the face piece was made of synthetic rubber. It had a simpler head harness and five points of attachment. The same canisters and carrier as with the GM30 were used.

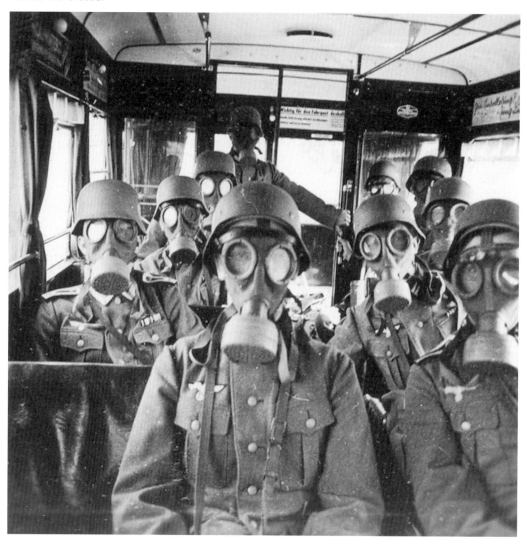

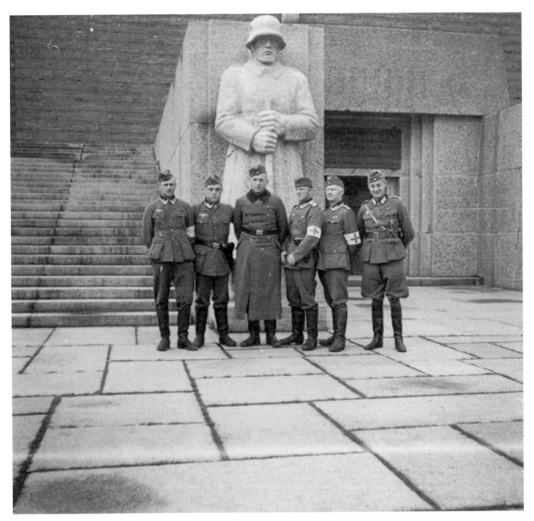

Members of the medical company stand in front of the monument to the battle of Tannenberg. This monument was erected at Hohenstein, then in German East Prussia. Hohenstein is now in Poland and renamed Olsztynek. It commemorates the battle between the Germans and the Russians in August 1914; actually the second battle of Tannenberg, as one had taken place between the Teutonic Knights and the Polish Lithuanian forces in the early fifteenth century. In the 1914 German victory 92,000 Russians were taken prisoner and 30,000 were killed or wounded. August, which was the month in which this photograph was taken, would have seen a celebration of the anniversary of this battle.

The medical personnel are standing in front of one of the two 13-ft statues that guard the entrance to a crypt that became the mausoleum for Field Marshal Paul von Hindenburg. He had commanded the German troops in the battle. When the monument's foundation stone had been laid in 1924, 60,000 German Army veterans had attended. Hindenburg had been laid to rest on 7 August 1934 and his remains were evacuated on 20 January 1945. A day later the Germans blew up the entrance tower. The Russians tore down the monument in 1949 and used the materials to build the Palace of Culture in Warsaw and the headquarters building of the Communist Party. Nothing remains of the monument today.

Three men await orders to move beside their ambulances and other vehicles in this photograph. The distances that these medical units would have to cover during the Polish campaign were enormous. Demolished railroad bridges were a problem, but these were quickly repaired so that specially equipped hospital trains could evacuate them. Air ambulances were also used and regular transport planes pressed into action. A medical company would include a squad staff of a medical officer, pharmacist, sergeant major paramedic, sergeant of the vehicle squad, two couriers and a driver. The communication group would have a small, four-man telephone squad. The ambulance section would have an officer, three non-commissioned officers and forty-six men. The main aid station would have four officers, six non-commissioned officers and forty men. The bulk of the men in the ambulance section would be stretcher bearers.

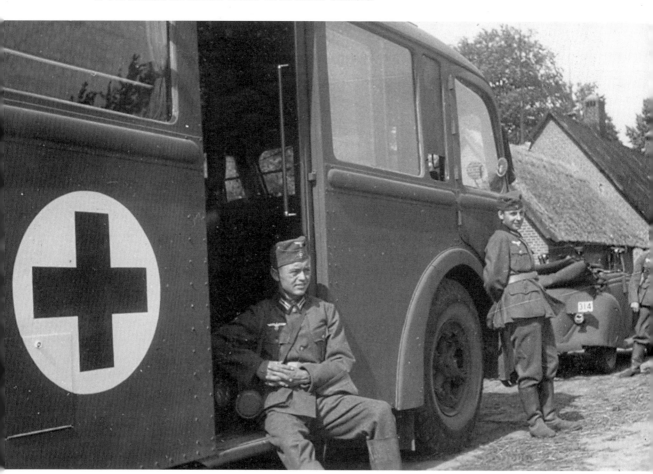

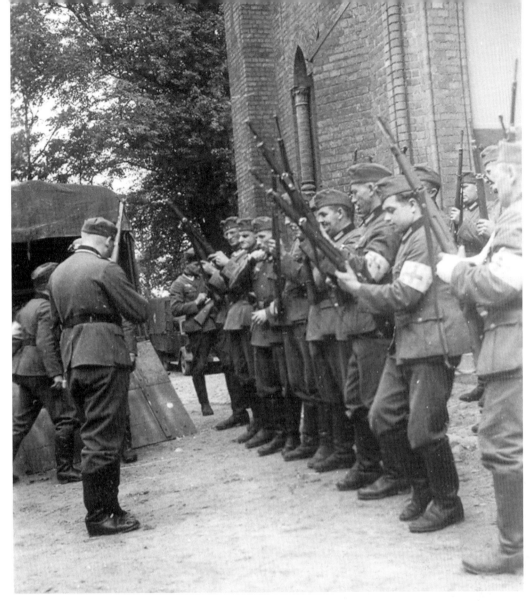

Men from the medical company are undergoing rudimentary rifle training in this picture. It is clear from the lack of precision that these men's experiences with firearms were rudimentary to say the least. Nonetheless, they would be expected not necessarily to operate in an offensive role, but be capable of defending themselves. They were, after all, an integral part of the infantry division and battalion. The officers of the unit were picked not only for their professional ability, but also for their qualities as leaders. University professors would also be attached to operate as consultants. There would also be auxiliary surgeons who would carry their own surgical instruments. It became obvious during the Polish campaign that it was not advisable to send these men any further forward than the divisional aid station. The road conditions in Poland were particularly bad and the motorised medical units would bear the brunt of the burden. The horse-drawn medical companies simply could not keep up with the rapid military operations. Men such as these would have to follow combat units as closely as possible; they would have to establish medical facilities in even the most primitive of conditions. If possible they would use existing hospitals, schools or public buildings.

This is possibly Wyszków, on the banks of the Bug River in north-eastern Poland. However, there are in fact three similarly named towns in Poland and unfortunately this does not help us either identify which sector of the theatre this unit was operating in, or when it was taken. Nonetheless, Wyszków is just 55 km to the north-east of Warsaw. A Polish operational group, consisting of three infantry divisions, was active in this area of the northern front. It included the 1st Legion's Infantry Division, one of the most experienced and best equipped of the Polish divisions, which had seen service in 1919 and 1920. It was partially mobilised again in March 1939 and became fully mobilised on 4 September, when it made contact with enemy troops.

By 7 September it was outnumbered by around three to one and slowly retreating to the south, in the area of Pultusk. It fell back to defend the river line between Wyszków and Kamienczyk. The division held back German attacks and began to withdraw towards Kluszyn.

On 11 September forward German units had already taken the town and the division forced them out during heavy night fighting. On 13 September the division launched a series of counterattacks on forward German positions. Although successful, the division suffered heavy casualties and was badly disorganised. It was forced to fall back and shortly after 22 September the division effectively ceased to exist.

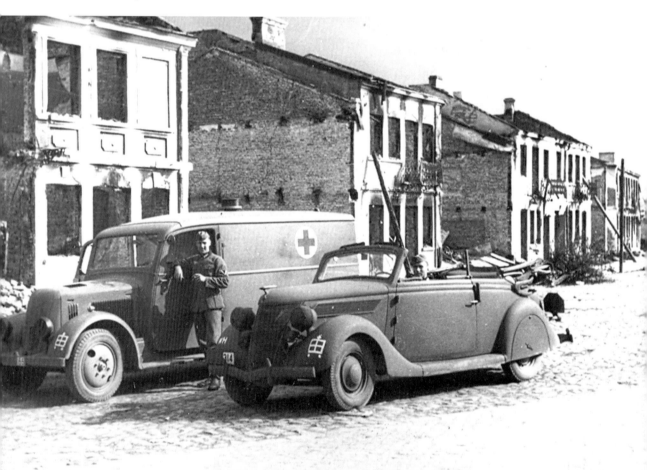

The medical company passes a long line of patiently waiting Polish prisoners of war. These men still appear to be armed and have not yet surrendered their weapons; many of them still appear to have rifles, pistols and ammunition. Every German soldier in the Polish campaign was inoculated against communicable diseases, as Poland had prevalence for typhoid. There were a number of dysentery cases. The troops were also well trained in hygiene and despite concerns smallpox did not break out. All of the wounded were also inoculated against tetanus.

These Polish prisoners are wearing a variety of variations of the basic uniform. The man on the front, right of the photograph wears a M1939 Rogatywka garrison cap. The majority of the other men, barring those with civilian caps, are wearing the M1937 field cap. The men have already been deprived of most of their equipment and it appears that most lack their M1933 backpack with blanket and their M1931 mess kits.

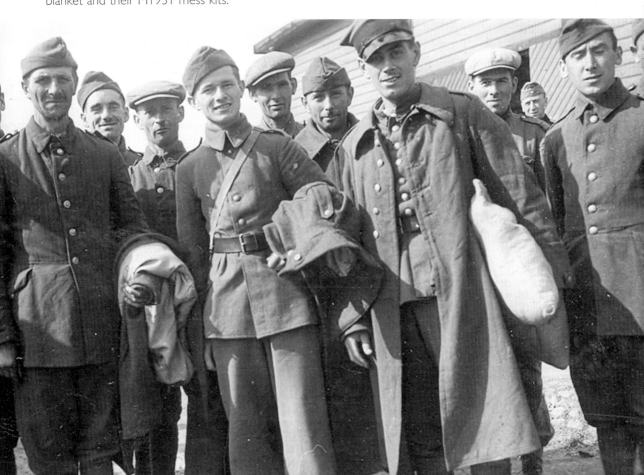

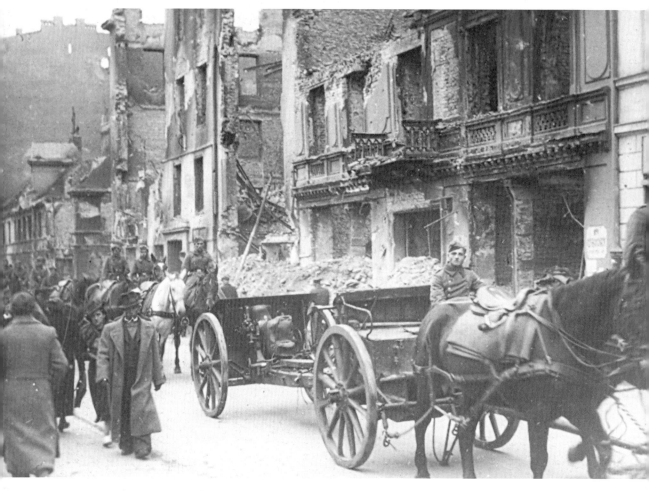

Horse-drawn German artillery passes along a bomb-shattered Polish street. This photograph was also part of the medical officer's collection and by this time the medical unit would have probably set up in more permanent accommodation in occupied Poland. From the outset the occupation was difficult for the Poles; there were food and fuel shortages, as well as a lack of medical supplies. Any resistance brought immediate reprisals. For the medical unit, their posting to Poland would probably have been a temporary one. Unfortunately, it is not clear whether or not they were shipped west to become involved in the invasion of the Low Countries and France, or whether they remained in the east and were ultimately part of the offensive in 1941 against Russia.

This is a German ambulance with a sentry in less than ideal conditions. This photograph was presumably taken at some point in the winter of 1939, by which time Poland had been partitioned between the Germans and the Russians. The German annexed territory contained a population of about 10 million and enlarged greater Germany by 94,000 sq km. In addition to this there was a large block of territory that was placed directly under German administration. The Russian sector amounted to some 52 per cent of all of Poland's territory and a small area of land was also given to Slovakia.

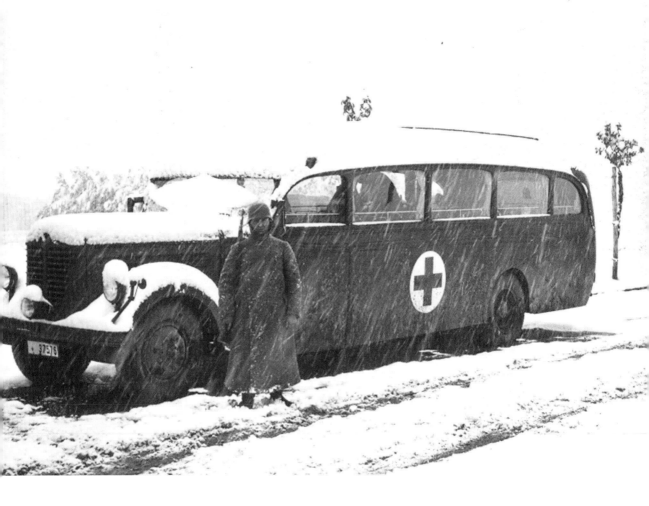

Members of the medical unit are seen here queuing up for their rations. The men are wearing a variety of uniform combinations and some have opted to wear their great coats. There was enormous variation, even in the great coat and in fact there were thirteen known styles. They were introduced at various times; the standard pattern was in field grey with a dark blue collar. As the war progressed, inferior-quality field grey great coats were supplied and there were specific variations for more senior officers, certain theatres, such as North Africa and Russia, and great coats made from animal skins and fur.

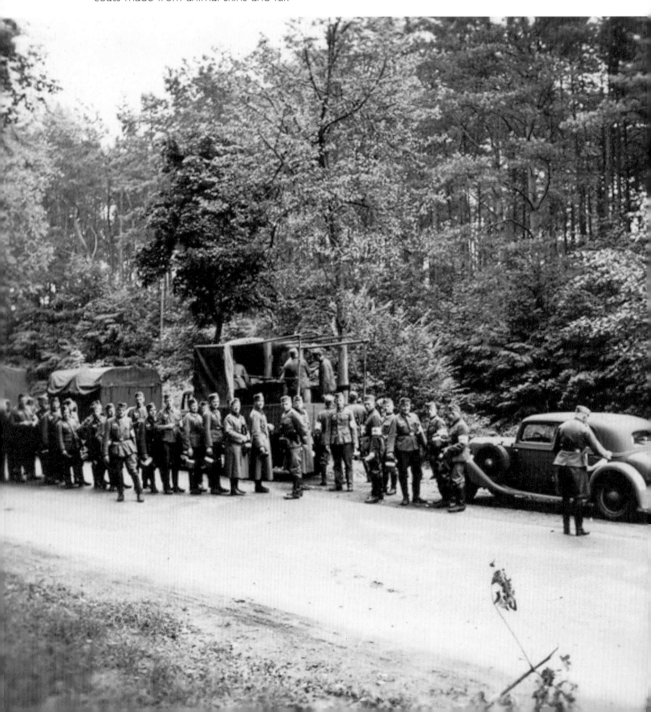

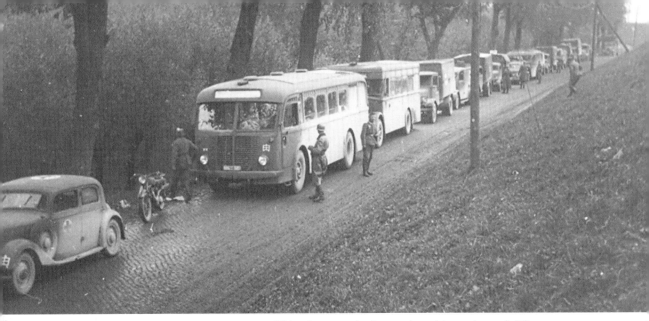

The German medical unit is on the move. This photograph shows the wide variety of different vehicles that were used by units such as these and adds weight to the suggestion that this particular medical unit may have been attached to either a panzer or a mechanised division. Note that all of the transport is motorised and that there is no sign of horse-drawn transport, which would have been the case for the majority of the infantry divisions.

Men of the medical unit fall out to enjoy their meals and relax after receiving their rations from the field kitchen, mounted on the back of a truck. When not following combat units, the medical service would be deployed to deal with possible epidemics and other medical problems. The corps medical officer would have the responsibility to deploy any of the medical elements within the divisions within the corps, with tasks such as assisting other divisions, assisting evacuation of patients to the rear, helping sort the sick and wounded according to medical requirements, or setting up collection or inoculation stations.

An interesting selection of slight variations on standard uniforms is shown here. Note that all of the men are rifle armed and that most of them have goggles, which indicates that they are part of a motorised unit. Two of the men, sitting at the front of the group, appear to be wearing motorcyclists' waterproofs. These were practical, double-breasted, rubberised motorcycle coats. They also appear to be wearing waterproof trousers. They would tend to wear these with army canvas and leather issue gloves or cloth mittens, overshoes and leggings or just with ordinary army boots.

Chapter Three

SS Officer's Album

If indeed this selection of photographs belonged to a *Waffen* SS officer, the involvement of *Waffen* SS units in Poland was relatively limited. The SS motorised infantry regiment, the *Leibstandarte* Adolf Hitler, was part of the southern group, as was the motorised infantry regiment *Germania* and as part of Group C there was also the motorised infantry regiment, *Der Führer*.

The *Leibstandarte* was attached to the 17th Infantry Division and it provided protection for the flank of the attack in the south of Poland. It was involved in combat with the Polish 28th Infantry Division and a supporting cavalry brigade. It then moved closer to Warsaw and was attached to the 4th Panzer Division. It proved itself to be an effective fighting force, but was notorious for burning towns and villages.

The *Germania* regiment became the nucleus of the SS *Wiking* Division. Comparatively speaking it was poorly trained for the Polish campaign, but it was always willing to fight. In fact, it was virtually overrun near Sadowa Wisznia between 14 and 16 September 1939, whilst protecting the flanks of armoured units and a large number of the men were taken as prisoners of war.

According to some accounts, the *Der Führer* regiment was not yet combat ready, although it is listed in the orders of battle for the Polish campaign. This unit had been formed in 1938 and as far as many accounts are concerned it was actually stationed on the West Wall, under the command of the 7th Army during the Polish invasion.

This therefore narrows the options down as to which SS unit the photographer belonged to and there are few clues in the uniforms to identify the exact unit. However, what is clear is that these photographs were taken either during or shortly after the invasion of Poland. They contain a mixture of captured and destroyed Polish aircraft and vehicles and there are also a number of photographs of wrecked bridges, which seem to indicate that at worst the photographs were taken very shortly after the invasion.

There is only one photograph that gives an indication as to the precise location of the unit. This is a photograph of a bridge over the San River in south-eastern Poland, and a tributary of the Vistula River. The photograph only reveals *Rzeka San*, which means River San. It may well be that this unit arrived in Poland possibly as part of of the occupation forces shortly after the Polish surrender.

These men are wearing M1938 field service caps, manufactured in field grey cloth. The cap was designed so that the sides could be pulled down and worn around the ears. The sides of the cap, towards the front, were scalloped to allow clearer vision when the cap was worn like this. The cap was also designed so that it could be worn under a steel helmet. With the possible exception of the man in the centre, the men are wearing black leather marching boots and M1936 service tunics.

A group of the men in the unit are wearing a mixture of regulation uniform and their own civilian clothes. The basic idea behind the M1936 single-breasted service tunic was that it was both smart and practical. It was manufactured in field grey and was a mixture of wool and rayon. It had four box-pleated patch pockets and five field grey-finished metal buttons. There would also be a button to each of the four pocket flaps. The collar was faced in a dark blue-green material. This material was also used as a backing cloth for the national emblem, on the right breast of the jacket. The same material was also used as backing cloth for the collar patches and arm rank insignia.

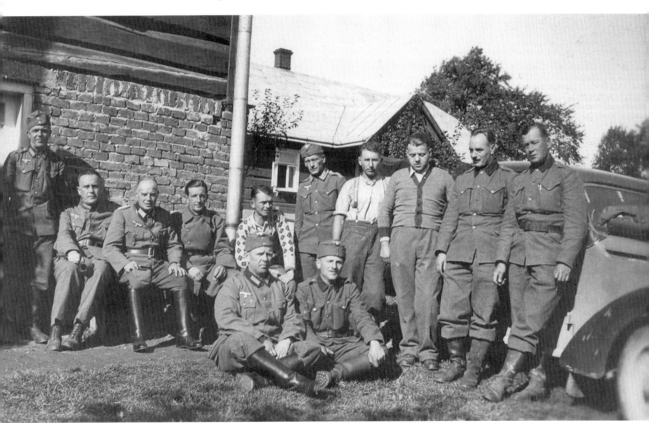

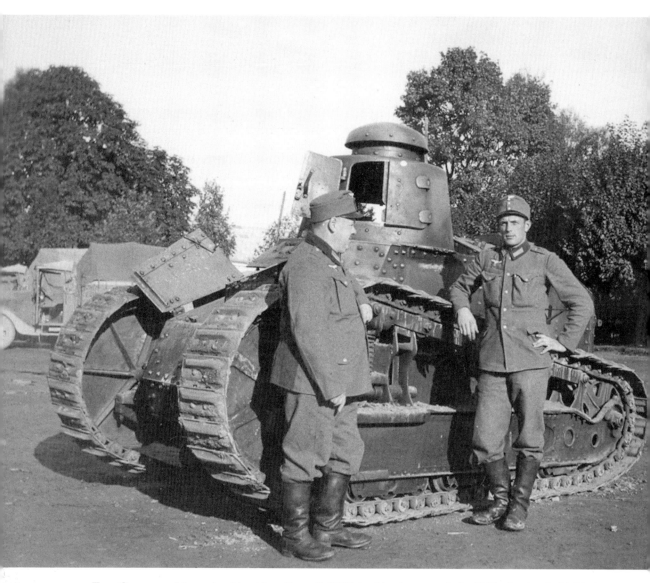

Two German soldiers stand beside a Renault FT17 in this photograph. In 1919, the 1st Polish Tank Regiment was created in France and equipped with 120 of these vehicles. In June 1919 the tank regiment returned to Poland, making Poland at the time the fourth largest armoured power in the world. The FT17 had seen its debut in battle in May 1918 and although obsolete by the Second World War, it was still in service with the Polish Army.

More of the unit are assembled around one of the captured Polish FT17s. The FT17 was used in the Polish-Soviet war and fought around Warsaw in August 1920. By the mid-1920s the Poles had made some modifications to these vehicles and some were fitted with new tracks, had improved fuel consumption and were less noisy. In 1926 twenty-seven FT17s were built in a Polish factory in Warsaw. During the period 1930 to 1936 the Poles still deployed 112 FT17s and had a further twenty-seven that were used as training vehicles. These may well have been the ones that had been produced in Warsaw in 1926.

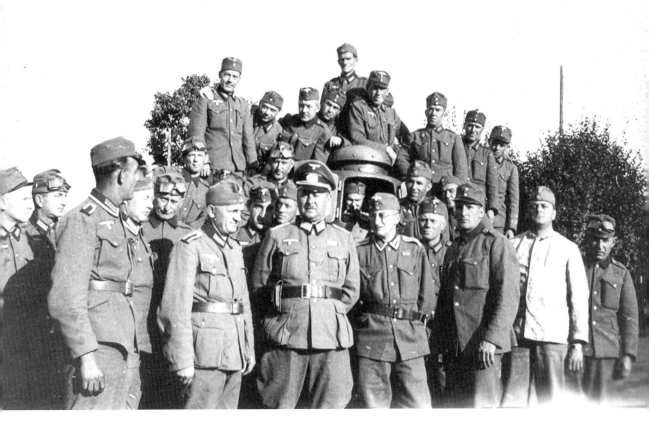

A number of the FT17s, all captured by the Germans are shown here. The Polish Army still had 102 FT17s in front-line service in 1939. Seventy of these were part of the 2nd Armoured Battalion and the other thirty-two were in a pair of armoured training units. The 2nd Armoured Battalion had three light tank companies (111, 112 and 113). They were mobilised on 6 September 1939. It was the 111th Company that ran into German forces first, losing two tanks to a reconnaissance unit belonging to the Kempf Panzer Division. The remaining tanks of the 111th were captured on 16 September.

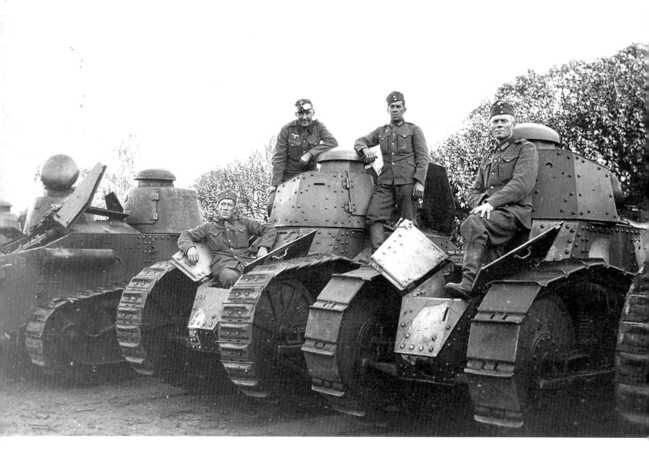

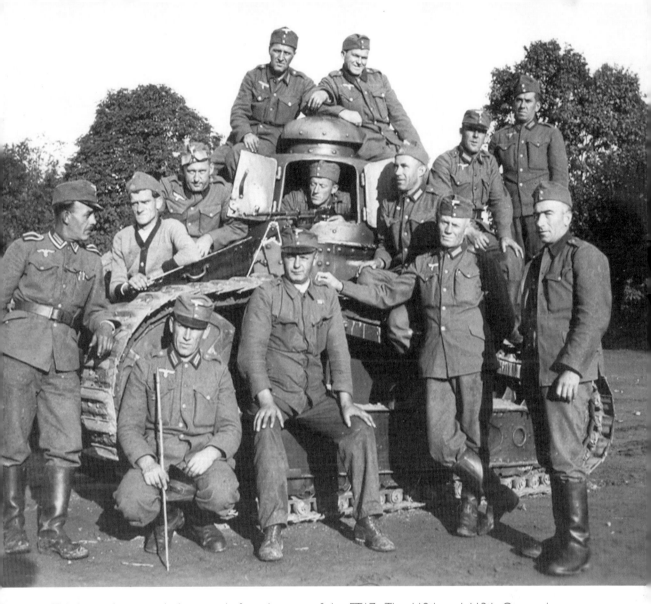

This is another posed photograph, featuring one of the FT17s. The 112th and 113th Companies were deployed in defensive positions around Brzesc. They were attacked on 14 September by the 10th Panzer Division. Twelve of the 113th Company's tanks were destroyed in combat with the German 8th Tank Regiment. By 16 September 1939 the Polish positions had been overrun and the majority of the tanks were abandoned.

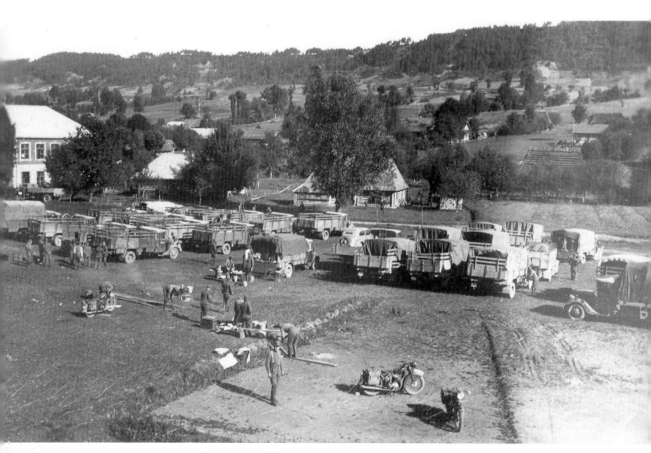

This is a panoramic view of a German supply column that is parked in a Polish field. The most common German truck was the Opal Blitz. It came into service in the 1930s and over 100,000 were built. Many of them were modified to become fuel trucks, radio cars, buses and some would even carry their own armament, such as anti-aircraft guns. Although the truck was light it could carry a considerable amount of weight and it had a reliable six-cylinder engine. It was certainly one of the toughest and most reliable vehicles during the Second World War and it was used in every theatre.

This is a German 105-mm howitzer and its crew. This weapon was the standard divisional field artillery at the beginning of the Second World War. It had a hydro-pneumatic recoil system and a heavy but simply designed breech mechanism. It had a maximum range of nearly 13,500 yards and could either be tractor or horse drawn. A light tractor would be perfectly capable, but when horse drawn it would need a limber and a six-horse team.

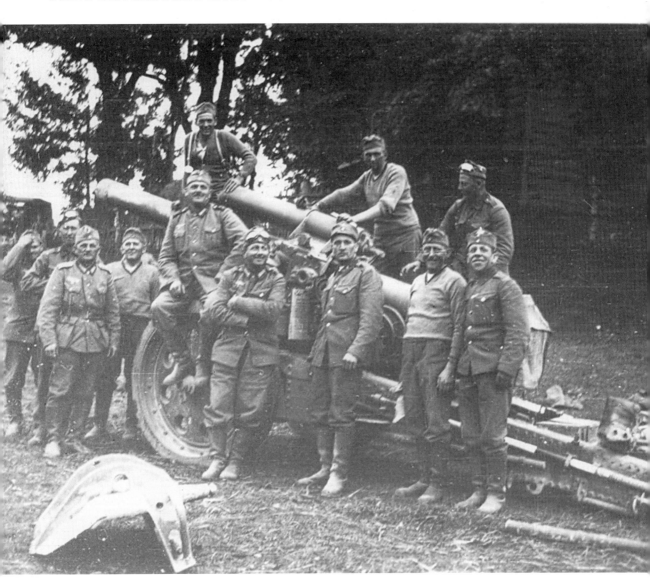

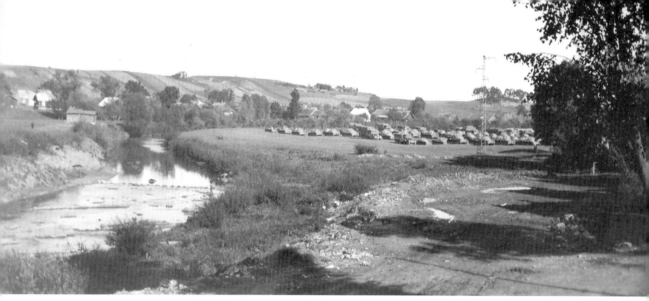

A collection of German armoured fighting vehicles and soft skins are parked beside a tributary. It is interesting to note that there is no sign of any sentries or personnel to guard this vehicle park. We must therefore assume that this photograph was taken at some point after the capitulation of the Poles. The German Army had around 1,500 tanks when the Second World War broke out. Many of them lacked fire power and had relatively thin armour. The vast majority of the tanks were Panzer Is and Panzer IIs. By 1941 both tanks were largely obsolete.

This is a pair of wrecked Polish aircraft; both appear to be biplanes, caught on the ground either by German bombers or fighters, or perhaps destroyed by the Poles to prevent them from falling into German hands. Despite being obsolete, the Polish PZLP11 fighters managed to shoot down large numbers of German aircraft. The fighters were grouped into fifteen *escadres* (a wing). The aircraft on the right of this photograph does not appear to be a PZLP11. However, the PZLP11 was perfectly capable of dealing with more up to date aircraft. Captain Mieczyslaw Medwecki, flying one of these, shot down a Stuka at dawn on 1 September 1939. This was the first aircraft to have been shot down in the Second World War. Just minutes later his wingman, Wladyslaw Gnys, shot down a pair of Dornier Do17s.

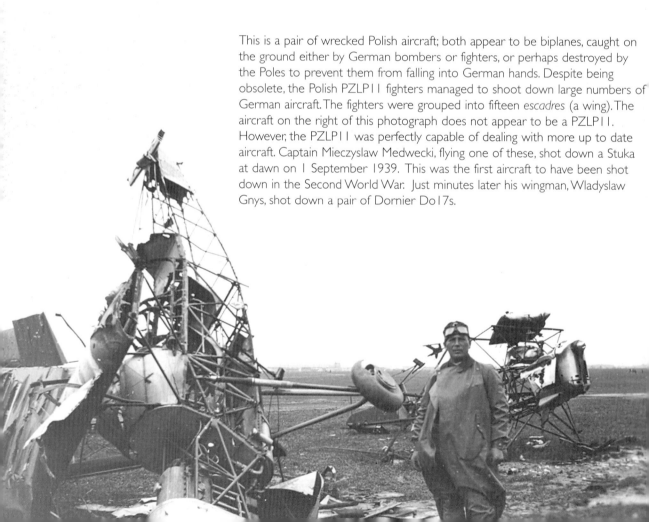

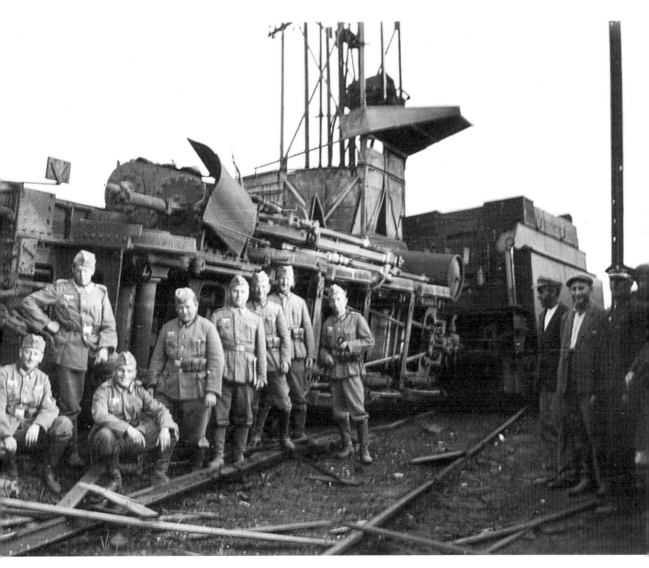

German soldiers pose beside a wrecked Polish train here. On 1 September 1939 Polish railwaymen at Szymankowo managed to blow up a bridge over the Vistula, stopping a German armoured train from entering Polish territory. Whilst a large amount of Polish locomotives and rolling stock were destroyed, a large proportion of it fell into Russian hands in the east. The Germans targeted the rail network even before the official outbreak of the war; a bomb was planted at Tarnow railway station and it exploded, killing twenty and wounding thirty-five. The bomber was revealed to be a Pole of German extraction and he had been operating with other German saboteurs.

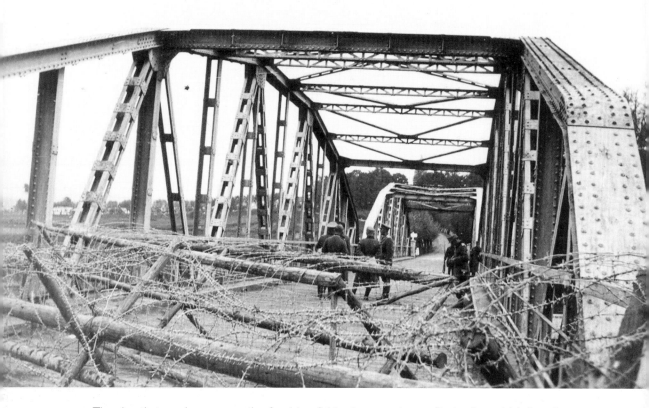

The sign that can be seen on the far side of this photograph says *Rzeka San*, which literally means San River. Unfortunately, this does not help us identify precisely where this location is in Poland, as the San River, being a tributary of the Vistula, has a length of 433 km and is the sixth longest Polish river. The San River was one of the major defence lines that the Polish Army set up from 6 September 1939. The line was eventually broken by the Germans on 12 September. The San River was also the demarcation line between German and Soviet troops, according to a *communiqué* issued on 22 September 1939. This may well explain why this bridge is so heavily defended, with log barriers and barbed wire. On the far side of the bridge in this picture is German-held Poland.

This is another view of the bridge over the River San. The city of Przemysl, on the San River, was the point at which many ethnic Germans crossed into German-held Poland in January 1940. Heinrich Himmler was there to personally greet them. An enormous number of refugees had crossed the San River trying to escape Soviet-occupied Poland in September 1939. On 26 July 1942, again at Przemysl, there was a violent confrontation at the bridge over the San River when the local garrison commander, Major Max Liedtke, ordered his men to shoot any member of the SS that tried to deport eighty Jews that he was protecting in his headquarters. The major was transferred to the Russian front. He was captured by the Russians and died in a labour camp.

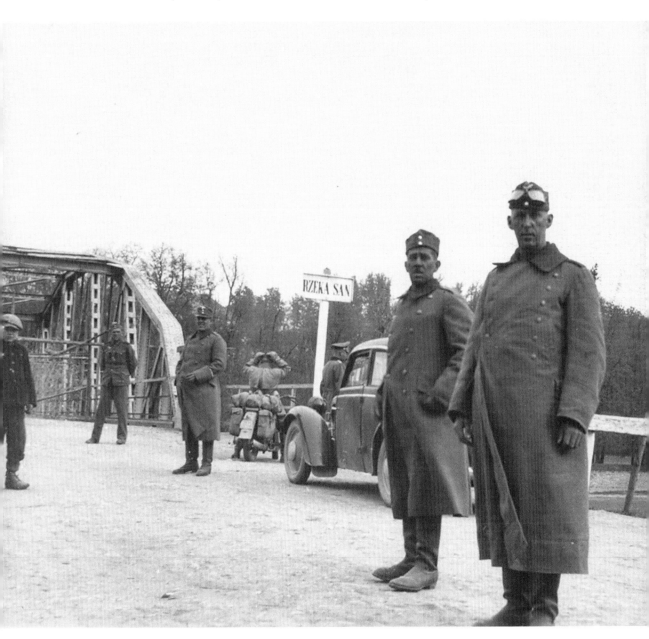

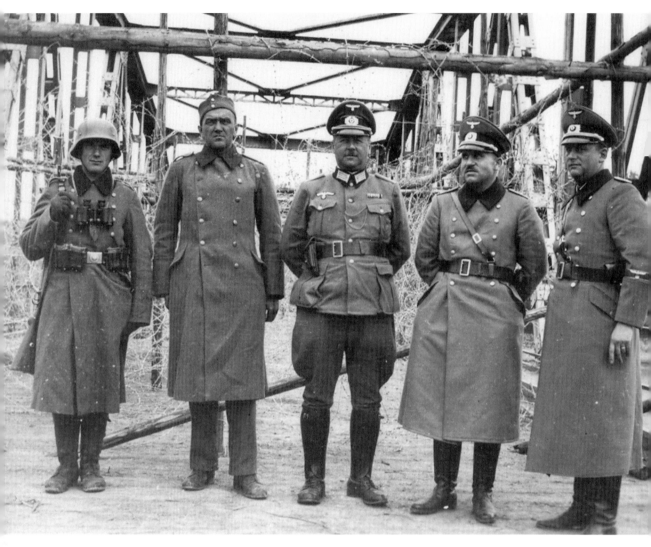

This is a close-up of some of the officers on the bridge over the San River. The three officers on the right of the photograph are wearing the uniform cap. Army officers below the rank of general all wore the same basic style. The peak of the cap was shiny black and had a slight ridge running along the edge to the peak. The insignia was in white metal. The national emblem, an oak leaf cluster, was also in white metal. There was a thin piping around the crown of the cap and around the top and bottom edges to the dark blue-green cap band.

This is a collection of damaged, mainly civilian Polish aircraft, although there are Polish Air Force aircraft to the right of the photograph. The airport at Katowice was one of those targeted from the very first day of the Polish invasion. The main airport for Warsaw had moved from Mokótow Fields in the 1930s to a new, central airport at Okecie. German reconnaissance showed that some fifteen Polish airfields had been abandoned in the days leading up to the invasion. The bulk of the German bombers belonged to the 1st Air Fleet and they brought five airfields under attack on the first day.

In southern Poland the main target was the air base at Kraków, which was carpet bombed, destroying around thirty Polish aircraft. It may well be that aircraft shown in this photograph were typical of the aircraft that they actually destroyed, mainly trainers and inoperable aircraft. The Poles had moved all of their front-line aircraft to tactical bases on the day before.

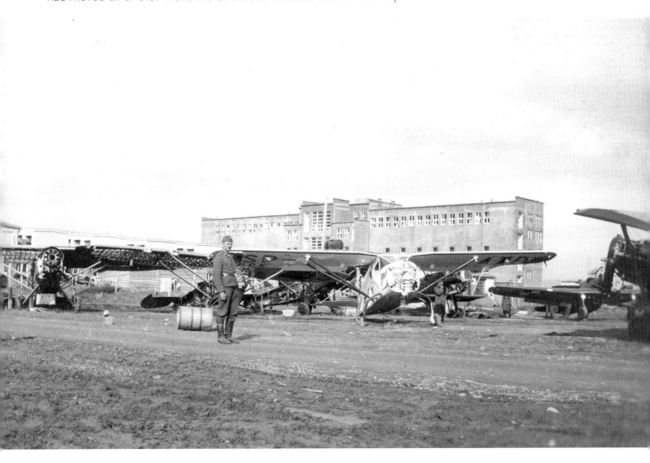

The wreckage of what very definitely appears to be Polish Air Force aircraft, primarily fighters. Initially, the Germans were surprised at the comparative absence of the Polish Air Force on the first day of the invasion. Certainly, bomber units were not risked on the first day. In moving their air units to tactical bases the Poles had prevented their air units from being able to concentrate. There were also extreme difficulties in communication. By default the Germans had gained air superiority. The major exception to this rule was over Warsaw, where they found it difficult to maintain local air superiority.

This photograph shows a wrecked bridge across a Polish river. At this stage there does not seem to have been any particular attempt to carry out repairs, although there are signs of a pedestrian walkway. By 25 September, with the Polish campaign virtually over, the Germans established four territorial military government commands, based around Danzig, Kraków, Lodz and Poznan. In overall command, including the tactical units, was Gerd von Rundstedt. The organisation was changed on 3 October when three frontier army commands were established. In all likelihood the officer that has taken this collection of photographs was involved in this part of the occupation.

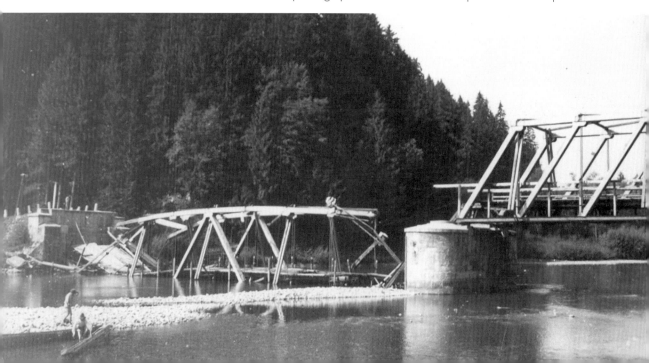

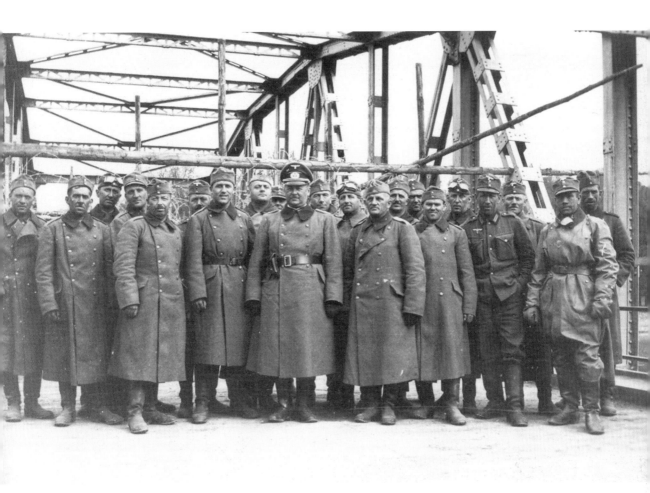

A good selection of different uniform types can be seen in this photograph. It seems to have also been taken on the bridge over the River San. Most of the men are wearing their German Army great coats, whilst the men on the right-hand side appear to be motorcycle despatch riders and are wearing rubberised waterproofs.

This photograph was presumably taken on the German side of the San River, as a large number of military sightseers arrive. Note that the Germans have requisitioned a wide variety of civilian vehicles and that in the rear we can see some examples of Polish civilian and military trucks that have been pressed into service by the Germans.

The writing on the truck, *Przeprowadzki*, simply means 'removals', so we must assume that this is a civilian truck caught in the fighting, having come off the riverside road and now firmly trapped in the shallow waters. There is considerable debate about whether or not the *Luftwaffe* deliberately targeted civilians in the invasion, but there are certainly witness testimonies that this was the case. There were instances when German aircraft bombed isolated farms and even columns of undefended refugees, trying to escape the fighting. There were also instances when any motor transport was fired on whether or not it belonged to the Polish Army.

German heavy trucks cross a ford in Poland. The prime suppliers of 3-ton trucks used by the German Army were Mercedes, Opel and Bussing-NAG. These manufacturers made both infantry carriers and trucks for cargo and supply. Volkswagen tended to produce field cars, such as the Kübelwagen and the Schwimmwagen (amphibious car), both of which were broadly based on the Volkswagen Beetle. The Kübelwagen was so called as many likened it to a tub with wheels and *kübel* in German means tub or bucket.

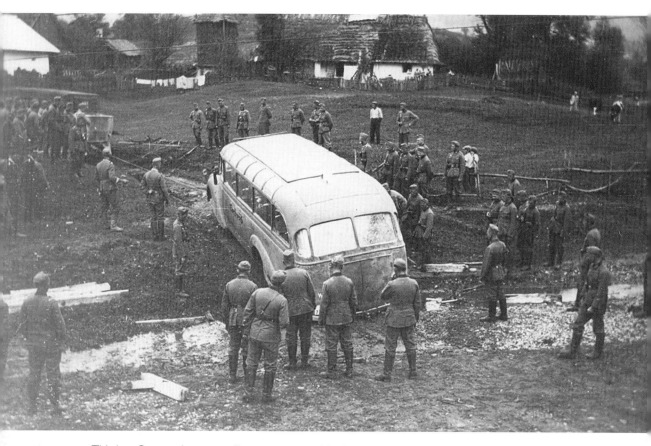

This is a German bus, struggling across a muddy depression with a large audience looking on. There were a number of versions of the Opel Blitz, which were used as buses, including the 3-ton, the Opel Blitz 3.6-ton, the 2.5-ton and the 1-ton. The Opel Blitz 3.6-ton was a thirty-seat bus and produced from 1939. Production finished in 1944, by which time nearly 3,000 had been constructed. There were dozens of different omnibuses that were used by the German Army based on commercial chassis of German and foreign manufacturers. Many of the earlier buses were actually open-topped, which betrayed their civilian roots.

This is a civilian Ju52. It is possible to see the 'double wing'. The rear flap ran along the whole trailing edge of the wing, lowering the stalling speed of the aircraft. Originally, the Ju52 was a single-engine aircraft, but after seven prototypes had been tested it was clear that it was under-powered. All of the Ju52s were therefore built with three radial engines. Before the German aircraft industry was nationalised in 1935 the Ju52/3M was produced as a seventeen-seat airliner. Passengers could fly from Berlin to Rome in eight hours. Lufthansa eventually built up their fleet to eighty and flew numerous European, Asian and South American routes.

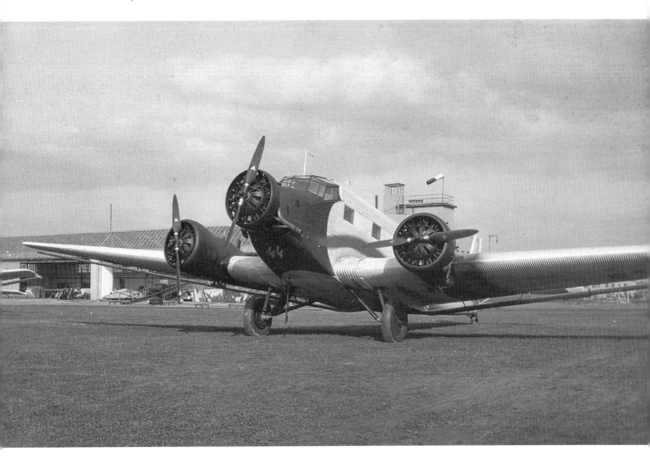

This is a pair of military Ju52s. A bomber variant was used during the bombing of Warsaw in September 1939. However, its principal use now became that of a transport aircraft. As the Ju52 was lightly armed and with a relatively slow top speed it was extremely vulnerable and always needed fighter escort. Hitler used a civilian Ju52 for his 1932 German election campaign. He had his own personal Ju52. Production of the aircraft continued even after the Second World War, with nearly 600 being built. The aircraft continued in service until at least the early 1980s, with the Swiss Air Force operating the last three of their remaining machines.

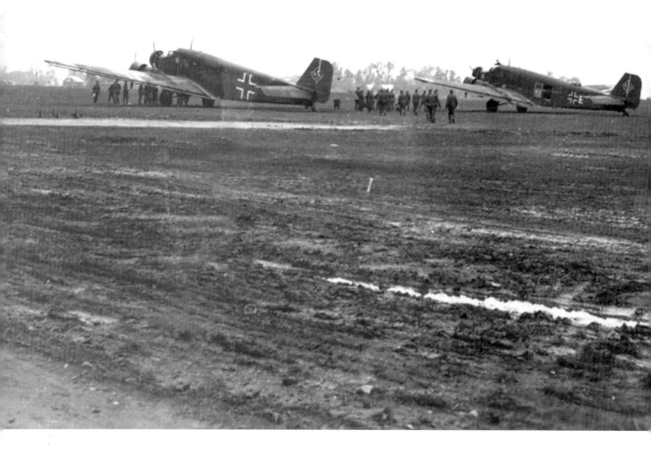

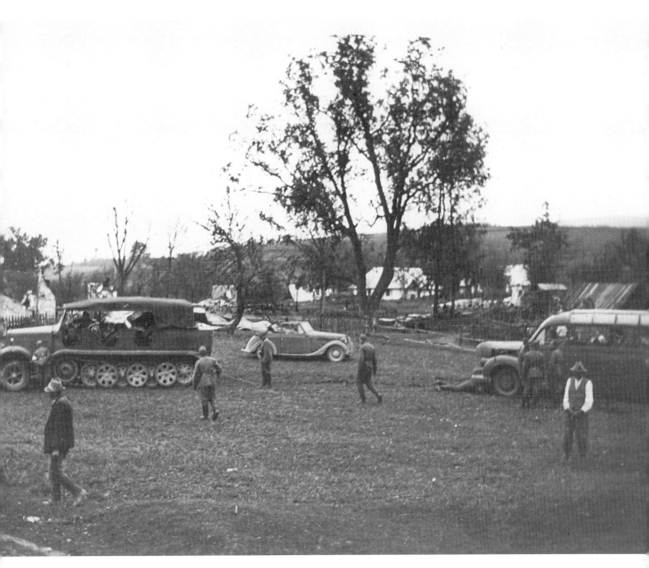

An SdKfz 7 is towing a German military bus in this photograph. The SdKfz 7 was a real workhorse for the German Army and was the main tractor used for the 88-mm FlaK gun and the 150-mm howitzer. As we can see in this photograph, the German soldiers are using the winch, which was attached to the majority of SdKfz 7s. This version of the SdKfz 7 is the basic model with open bodywork, although the canvas roof has been put up over the seating. Because of its heavy power it was often used as a recovery vehicle.

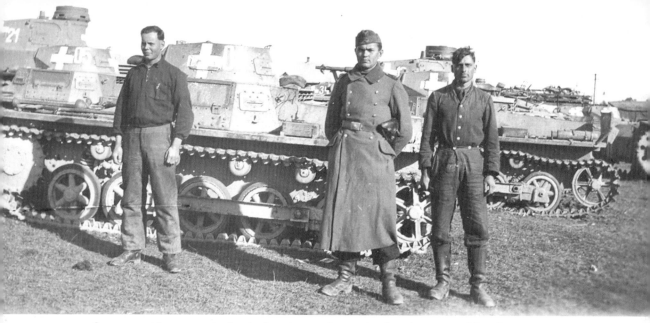

German soldiers pose in front of an impressive park of early panzers. The Germans started to secretly develop their armoured tactics in the 1920s. They were an integral part of the German *blitzkrieg* tactics. The early war tanks, which can be seen here, were inferior in many ways to their French and Russian counterparts. It was the way in which they were used that made them so effective. The crews were particularly well trained and they had excellent communications. Most importantly, they were used in a combined arms role, with infantry and air cover.

Two wrecked and stripped trucks abandoned amongst the remains of a bridge. Although the Polish campaign was a relatively short one, the Germans sustained heavy losses in both aircraft and vehicles. Tank losses alone amounted to an entire armoured division and upwards of one in four of the aircraft deployed were either destroyed or badly damaged. Although the Polish campaign, and later the campaigns against the Low Countries and France, are often cited as examples of the *blitzkrieg* tactic, the deciding factors that led to the defeat of Poland were the Poles' own poor communications and the effect of the German artillery on Polish units, which often broke up defence lines and concentrations of troops before they could be used to any great effect.

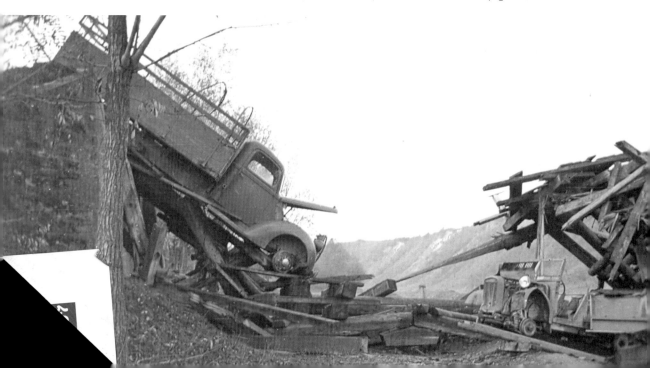

Members of the unit pose beside a road here. It is interesting to note the variation of headgear that is being worn by these men. Few of them seem to be armed and none have their steel helmets. The officers are wearing their uniform caps (*die schirmmütze*) and most of the other men are wearing their field service caps. There were various styles and designs; all of them were manufactured in field grey cloth. Some of them appear to be wearing caps that resemble the mountain cap, which was worn by mountain units and *jäger*. This was based on a design of the Austrian army service cap.

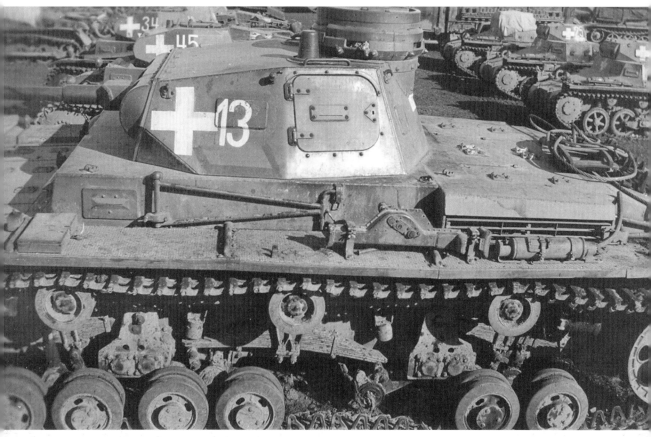

This is a close-up of some of the panzers that appear to be temporarily mothballed, judging by the canvas covers that have been placed over the top of some of the tanks. One of the great myths of the Polish campaign was charges by Polish cavalry against German tanks. The myth probably originated from a German propaganda film that purported to recreate a skirmish around Krojanty in Pomerania on the evening of 1 September 1939. In fact, elements of a Polish cavalry brigade attacked German infantry in armoured personnel carriers when they were ambushed. The Polish cavalry, in fact, had mounted a sabre charge against German infantry.

This is a final, posed shot of members of the unit. There are some familiar faces in this photograph, which have regularly occurred throughout the album. The Germans were not to have a particularly quiet time during their occupation of Poland. From the outset Polish partisans became active and their activities were certainly encouraged by the Russians as the war progressed. The Germans mounted a number of punitive operations against civilians and supposed hotbeds of partisan activity. The resistance against the Germans culminated in an uprising by the Polish Home Army in Warsaw in anticipation of the Russian advance on the capital. The Russians stood off and allowed the Germans to reduce the city to rubble after sixty-three days of fighting.

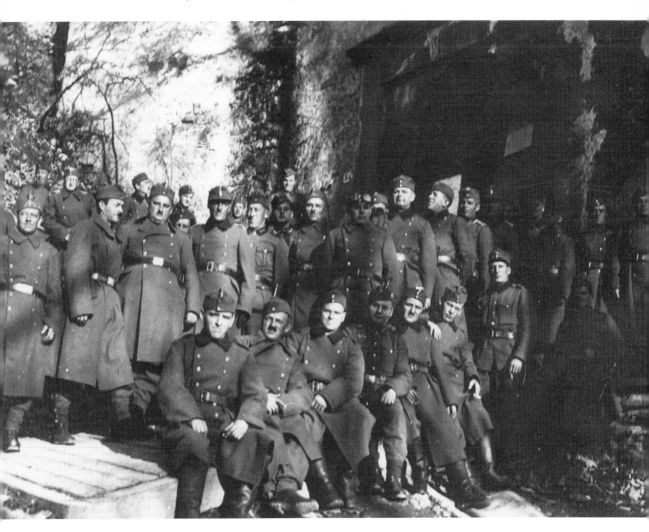

Bibliography

Davis, Brian L., *German Army Uniforms and Insignia: 1933–1945*, Arms and Armour Press, 1973

Deighton, Len, *Blitzkrieg: From the Rise of Hitler to the Fall of Dunkirk*, Pimlico, 2007

Fowler, Will, *Poland and Scandinavia 1939 to 1940*, Ian Allen, 2002

Hargreaves, Richard, *Blitzkrieg Unleashed: The German Invasion of Poland 1939*, Pen & Sword Books, 2008

Smet de, J L, *Colour Guide to German Army Uniforms: 1933–1945*, Arms and Armour Press, 1973

Sutherland, Jonathan, *World War Two Tanks and AFVs*, Airlife Publishing Ltd, 2002

Thomas, Nigel and Stephen Andrew, *The German Army 1939 to 1945*, Osprey, 1997